本书出版受广州美术学院"智慧乡村2019广美林茨艺大国际联合设计工作坊"（6050519720）项目支持

发现与演绎：汶川羌人谷工作坊研究实录

DISCOVERY AND DEDUCTION

杨一丁　温颖华　何伟　编著

中国建筑工业出版社

图书在版编目（CIP）数据

发现与演绎：汶川羌人谷工作坊研究实录 = DISCOVERY AND DEDUCTION / 杨一丁，温颖华，何伟编著. —北京：中国建筑工业出版社，2022.9
ISBN 978-7-112-27766-7

Ⅰ.①发⋯ Ⅱ.①杨⋯ ②温⋯ ③何⋯ Ⅲ.①艺术创作—研究—汶川 Ⅳ.①J04

中国版本图书馆CIP数据核字（2022）第155298号

本书作为中国广州美术学院与奥地利林茨艺术大学合作举办的"发现与演绎"工作坊的全程记录，全面介绍了合作的缘起、研究及教学工作中的观念与方法、研究过程中的发现、思考与成果。书中涉及空间设施营造、农作物生产与销售、家居生活与社交、传统用具制作、图腾崇拜、水利设施系统、节庆仪式和水土保护等多方面，适于城乡建设、建筑学、规划等相关专业的师生及从业者参考阅读。

英文翻译、校对：李骏铭
书籍装帧设计：CONS PROS设计事务所
封面插画：林梓晟
责任编辑：杨　晓　唐　旭
责任校对：张　颖

发现与演绎：汶川羌人谷工作坊研究实录
DISCOVERY AND DEDUCTION
杨一丁　温颖华　何伟　编著

*

中国建筑工业出版社出版、发行（北京海淀三里河路9号）
各地新华书店、建筑书店经销
北京锋尚制版有限公司制版
天津图文方嘉印刷有限公司印刷

*

开本：880毫米×1230毫米　1/32　印张：6¾　字数：294千字
2022年9月第一版　2022年9月第一次印刷
定价：88.00元
ISBN 978-7-112-27766-7
（39758）

版权所有　翻印必究
如有印装质量问题，可寄本社图书出版中心退换
（邮政编码100037）

序一
Foreword I

随着社会经济的快速发展，人们生活水平迅速提高，生活方式和生活态度不断发生改变，我国城乡之间的关系也正面临转向城乡融合的关键时期。近年来在我国生态文明乡村振兴背景下更加凸显了乡村对于人居环境的重要价值。何为乡村？当下乡村的景观面貌、建筑风格、农业系统等，需要我们躬身俯察，于细微处找到乡村发展的印记，发掘乡村营造的智慧。

"乡村"是空间营造相关学科历来关注的一个热点方向，广州美术学院建筑艺术设计学院有着发挥自身在人才、科技、资源等方面的优势。本次以"智慧乡村"为题的国际联合工作坊是一次助力乡村振兴，深入思考和落实的积极探索。广州美术学院与奥地利林茨大学的师生从广州出发，前往四川汶川羌人谷村落，通过实地调研和日常观察，探讨乡村潜在的生活居住、生产工作、生态适应以及文化活动的方式，成功地向我们展示了羌人谷的人民长期与自然相处过程中尊重自然、敬畏自然和合理利用自然的精神信仰，反映了当地人民和政府在应对地震、水安全、农业发展、经济运营和提高人民生活质量方面的智慧。便利的交通和信息的普及也在不断拉近乡村和城市的距离，今天乡村的智慧不仅是本土村民在创造，也有政府和公益群体的力量，在共同合力营造智慧乡村。这些丰富的研究成果能够为乡村地区的调研、讨论思考和制定发展战略提供参照。

全球化视野下城乡发展的探索促进了此次活动的成功展开，广州美术学院非常重视国际化的交流与合作，东、西方高校之间的紧密合作能够为学科发展提供更开放、多元的价值。同时，广州美术学院服务乡村振兴是职责所在，基于自身学科人才优势，精准定位乡村人才、产业和社会发展多元需求，方能在乡村振兴战略中贡献智慧。

沈康
广州美术学院教授
广州美术学院建筑艺术设计学院院长
广州美术学院研究生处处长

With the booming development of economy and society, people's living standards are improving rapidly, and their life styles and attitudes are constantly changing. The relationship between urban and rural areas in China is also facing a critical period of urban-rural integration. In recent years, under the background of rural vitalization of China's ecological civilization, the importance of living environment in rural areas has been highlighted. What is rural? The landscape, architectural style, agricultural system and so on of the current countryside need us to bow down and observe, find the mark of rural development in detail, and explore the wisdom of rural construction.

"Country" is a hot spot direction which is always focused by space construction disciplines, Guangzhou Academy of Fine Arts School of Architecture and Applied Arts exerted it's own advantage in aspects of talents technology and resource, the international joint workshop entitled "Wisdom Country", was a assistance in rural vitalizing, by deep thinking and active practicing. Teachers and students from Guangzhou Academy of Fine Arts and Linz University of Austria set out from Guangzhou to Qiang Valley village in Wenchuan, Sichuan province to explore the potential ways of living, working, ecological adaptation and cultural activities through field research and daily observation. It successfully demonstrated the Qiang people's spiritual belief of respecting nature, reverence nature and rational use of nature during their long-term coexistence with nature, and reflected the wisdom of the local people and government in dealing with earthquakes, water security, agricultural development, economic operation and improving people's life quality. Convenient transportation and the popularization of information are also constantly bringing the distance between rural and urban areas. Today, the wisdom of rural areas is not only created by local villagers, but also by the government and the public interest groups, working together to create smart villages. These rich research results can provide reference for the investigation, discussion and development strategy of rural areas.

The exploration of urban and rural development from the perspective of globalization promoted the success of this activity. Guangzhou Academy of Fine Arts attaches great importance to international exchanges and cooperation, and the close cooperation between Eastern and Western universities can provide more open and diversified values for the development of disciplines. At the same time, It is the responsibility of Guangzhou Academy of Fine Arts to serve the rural vitalization. Based on its own talent advantages, Guangzhou Academy of Fine Arts can precisely position the diverse needs of rural talents, industry and social development, so as to contribute wisdom to the rural revitalization strategy.

Shen Kang
Professor of Guangzhou Academy of Fine Arts
Dean of School of Architectural Art and Design, Guangzhou Academy of Fine Arts
Director of Graduate Office, Guangzhou Academy of Fine Arts

序二
Foreword II

自工业革命以来，城市作为现代人类文明的主要载体，在不断被建构的同时也塑造着当代人类的工作生活方式、生产关系、思想文化和社会文明。乡村，作为一个既熟悉又陌生的概念，在建筑学、城市规划、社会学、地理学等领域一直处于"匿名"的状态。当城市发展进入后工业时代，乡村重新进入人们的视野，不再以一个遥远的、"乌托邦"般的净土或者人类生存环境的背景存在。更多地，学者将乡村作为城市研究的参照体系，开始反思全域城市化的必要性，以及重新发掘乡村作为人类生存和重新安居之地的可能。

在本次以"智慧乡村"为题的国际联合工作坊中，广州美术学院与奥地利林茨大学的师生以中国四川汶川羌人谷村落为研究对象，采用述行反转的方式，对村落的空间设施、生活方式、文化信仰、自然环境等方面进行了深入的观察和记录。工作坊的研究性教学活动丰富多彩，既包括双方师生在调研过程中与村民的互动、对诸多未知领域的讨论，还将研究成果运输到不同城市进行展览和传播，极大地激发了人们对乡村的想象和思考。这次国际工作坊的研究方式打破了传统以规划师、建筑师惯用的分析方法，即通过功能划分研究对象，并用对象划分空间的理性主义思维。相反，参与的老师和学生在这个特定村落中，通过对特定村民的行为、语言、信息、建筑、文字、图腾以及自然环境的观察，绘制出它们之间的内在联系或特定关系，并以此为基础，进一步挖掘其背后的意义和价值。这些丰富的一手资料将为我们研究乡村在未来自然与人文、生产与社区等方面提供多样性的思考维度。广州美术学院非常重视国际化交流与合作。我们与全球50多个不同国家的学校有密切的交流并建立了友好合作关系。我们热切地希望未来能够和更多的院校建立紧密的跨国学术合作，进一步推进类似"智慧乡村"国际工作坊的合作项目，朝着更多元、开放、前沿的方向迈进。

伍端
广州美术学院教授
英国剑桥大学博士
广州美术学院国际合作与交流处处长

Since the industrial Revolution, cities, as the main carrier of modern human civilization, are constantly being constructed and shaping the way of work and life, production relations, ideology and culture and social civilization of contemporary human beings. Countryside, as a familiar and unfamiliar concept, has always been in the state of "anonymity" in architecture, urban planning, sociology, geography and other fields. When urban development enters the post-industrial era, the countryside re-enters people's vision and no longer exists in the background of a distant, "utopian" pure land or human living environment. More and more, scholars take rural areas as the reference system of urban research, and begin to reflect on the necessity of global urbanization, and rediscover the possibility of rural areas as a place for human survival and resettlement.

In the topic of Smart Village international joint workshop, Guangzhou Academy of Fine Arts with the teachers and the teachers and students of the university of Linz, Austria to China's Wenchuan in Sichuan province Qiang village as the research object, uses the above line reverse way, the way of life in the village of space facilities, cultural beliefs, natural environment and so on carried on the thorough observation and record. The research-based teaching activities of the workshop were diverse, including the interaction between teachers and students from both sides and villagers in the research process, the discussion of many unknown areas, and the transportation of research results to different cities for exhibition and dissemination, which greatly stimulated people's imagination and thinking about the countryside. The research method of this international workshop breaks the traditional analytical method used by planners and architects, that is, the rationalist thinking of dividing research objects by functions and dividing space by objects. On the contrary, the participating teachers and students draw the internal connection or specific relationship between the specific village and the place, through the observation of the behavior, language, information, architecture, characters, totems and natural environment of the specific villagers, and further excavating the meaning and value behind it on the basis of this. These rich first-hand materials will help us to study the future of the countryside in nature and humanity, production and community and provide a variety of thinking dimensions. Guangzhou Academy of Fine Arts attaches great importance to international exchanges and cooperation. We have close communication and friendly cooperation with schools in more than 50 countries around the world. We earnestly hope to establish close transnational academic cooperation with more institutions in the future, and further promote cooperation projects like the Smart Village International Workshop, so as to move towards a more diverse, open and cutting-edge direction.

Wu Duan
Professor of Guangzhou Academy of Fine Arts, doctor of Cambridge University
Director of International Cooperation and Exchange Depa
rtment, Guangzhou Academy of Fine Arts

目录
Contents

I

发现与演绎 Discovery and Deduction	013
行与思的方法 Methods of Action and Thoughts	031
考察东门口村：思考与质疑 A Visit to the Dongmenkou Village: Thoughts and Doubts	046
灾后重建的村落日常生活 Daily Life of Village Rebuilt after Disaster	058
羌 Qiang	067

II

存在的图示 The Existed Totem	074
图形智慧 Graphic Wisdom	076
在这里 Being Here	082
系统与非正规 Systematic and Informal	084
水3 Water3	086
非正规解决方案 Informal Solution	092
农业的三个向度 The Three Dimension of Agriculture	096
龙舌兰 Agave	098
苹果的买卖 Apple	110
永续农业 Sustainable Agriculture	118
传统的角色 The Character of Tradition	122
锁的智慧 Wooden Lock	124
桑拿 A Warm House	128
日常的美感 Daily Aesthetic	132
杀年猪 Slaughter for the New Year	136
自然的美感 Natural Beauty	144
废物的价值 The Value of Waste	148
凳子的智慧 Stools Story	150
智果 The Fruit of Knowledge	156

沟通与叙事 Communication and Narrative	160
火炉与手机 Stove and Mobile Phone	162
羌秀 Qiang Show	168
述行绘图 Performative Drawing	172

III

四个展览和两次巡游 Four Exhibitions and Two Parades	178
时间线 Timeline	195
人物 People	199
回声 Echo	205

I

发现与演绎

Discovery and Deduction

发现与演绎
Discovery and Deduction

这个世界不仅是城市的，也是乡村的，城市生活条件很现代化也很丰富，颇受年轻人的喜爱，但乡村作为城市生活的重要支撑，提供食物、守护自然，同时也孕育大量的劳动力等，这些都为现代城市生活提供着必要的保障。

虽然乡村会持续存在，但是随着乡村生活系统的蜕变，在生活方式、工艺、技术、经济、文化等方面中所蕴含的智慧，常被认为过时而受到忽视和遗忘。无论从历史遗产意义还是从现实应用价值的角度，这都是巨大的文明浪费。

在本次智慧乡村的工作坊研究中，我们需要对具体的自然现象及其整体进行观察，也要有意识地理解自然与人类生活的关系。在过程中我们试图丢掉固有的成见，从某一命题开始大胆假设，基于各自知识背景，运用逻辑规则认真求证，并在群体交流中通过思辨和讨论，展开合理又有想象力的延展与表现。这既是采集记录，又是对前人经验的学习继承，也更有助于导出新命题进而增进创新能力。

项目缘起　广州美术学院与奥地利林茨艺术大学有着长时间的教学合作，彼此接收本科生及硕士研究生层次的交换生，学术往来关系亲密。

这次工作坊的发起和组织者之一郑娴女士，在广州美术学院建筑艺术设计学院攻读硕士研究生期间，就曾作为交换生前往奥地利林茨艺术大学学习交流，后又在该校空间策略系攻读博士学位，她也曾于2015年、2017年两届深圳城市建筑双年展中参与、组织团体项目参展及相关活动。她为两校之间的学术交流进行了大量的联络工作，并在本次活动的前期策划和成果展示方案等方面做了很多准备。

广州美术学院建筑艺术学院也曾邀请本次工作坊的两位林茨艺术大学教授Rianne Makkink和Ton Matton来校做专题学术讲座，在交流活动中对彼此的研究和教学工作深感认同，并多次表达开展合作研究性教学活动的意愿和期待。

2018年末我们两校相关系科共同策划，以中国四川省汶川羌人谷村落为对象，开展国际学术合作与研究交流，并拟以该项目工作坊的成果作为参展2019年深圳城市建筑双年展的作品，项目计划得到两校和深双展组委会的批准和支持，经过前期的联络和准备，项目于2019年11月起正式开展活动。

活动过程　"智慧乡村·发现与演绎——2019汶川羌人谷工作坊"由中国广州美术学院建筑艺术设计学院（3名教师及9名硕士研究生）与奥地利林茨艺术大学空间策略系（4名教师，10名研究生）共同组成团队,另有原林茨艺术大学教授Rianne Makkink作为特邀学术顾问参与指导工作。

2019.11.25　工作坊成员代表考察深双展福田主展区展场。

2019.11.26-27　工作坊开始时，全体成员于广州美术学院进行了"杨一丁：设计·关系""Rianne Makkink：工业文化地景实践""Josef Maier：物件工作""郑娴：演绎性绘画"学术讲座交流，借此了解两校各自的研究理念和特点，为工作坊考察阶段做准备。

2019.11.28-12.08 工作坊进行过程中，全体成员赴四川省汶川，在东门口村(羌人谷)驻村并开展为期十天的考察工作。其间开展了实地调研和集体讨论，还聆听了当地村民代表有关羌文化历史以及村落变迁的介绍，并于考察阶段结束时，在东门口村举办现场展览，其时适值冬至，工作坊成员与村民共同举办联欢及节庆巡游。
2019.12.10-12.13 工作坊借用深圳雕塑院的空间，做考察工作的成果总结与梳理，编辑制作相应的视频成果，并于结束时在周边社区举办舞狮及巡游活动。
2019.12.20-12.22 工作坊成果于深双展布展及开幕。
2019.12.23-12.27 工作坊成果广州美术学院汇报展筹备、布展，并于27日正式开展。
2020.05 因新冠肺炎疫情之故，工作坊成果于奥地利林茨艺术大学以线上展示形式展出。

研究内容 在这个以"智慧乡村"为题的国际工作坊中，两个学校的教师和研究生一起，分别针对空间设施营造、农作物生产与销售、家居生活与社交、传统用具制作、图腾崇拜、水利设施系统、节庆仪式和水土保护等方面开展了调研，并结合自己的专业背景和学术兴趣，完成了各自的成果和作品，它们既个性鲜明，又与其他作品交织成若干条有后续深入研究讨论的线索。

有趣的是，本次工作坊的合作并非是惯常的中外学生混合结为小组，在中外导师的指导下共同完成各自主题研究的方式，而是以学术背景为基点，由对场地问题的独特发现，自由组合并各自开展相对独立的调查与研究。在过程中各个阶段节点透过讨论交流形成对照，发现价值观相近的同类，在彼此欣赏前提下，建立起相互帮助与协作的关系。另外，导师们不只作为指导的角色，也都在组织引导之余做了反映个人兴趣和思考的观察与探索作品。

有趣的对照
存在的图示 ——村落里有许多房屋涂有鲜艳的各式图腾和象形文字符号，其语义未必清晰，或许只是因美化的需要而存在，一组学生以这些图案作为虚拟的语言，尝试通过与村民一同绘制图形石，建立起对它们的延伸理解和组合表达；而另一位学生则对村里的宣传标语感兴趣，试图梳理其表象与内涵的一致与反差，以理解人在村落里的多层次存在感。

体系与非正规 ——乡村建设的一个重要举措就是改善基础设施的条件，一组学生关注水在村落中的各种状态及其所形成的三维网络系统，对其进行了空间图解和存在问题的捕捉，完成了专业化的图示成果；而一位导师则对村落营建体系中的各种实施细节更感兴趣，观察收集了一系列"非正规"但体现生活智慧的片段，并与当代艺术设计的经典作品作了有趣的图像对比，以显现独立细节背后的共同逻辑。

农业生产的三个向度 ——农业生产是乡村存在的核心价值之一，其过程和形态引发了多方面的探究，一组学生由吃到香甜的苹果开始，对此地特产苹果的种植、运输和销售过程进行了跟踪调查，了解其中有关地理气候、劳作方式、家庭生产组织、电商价值等多方面资讯，在研究之余还成为热情的推销者。一位年长的学生则专注于农业生

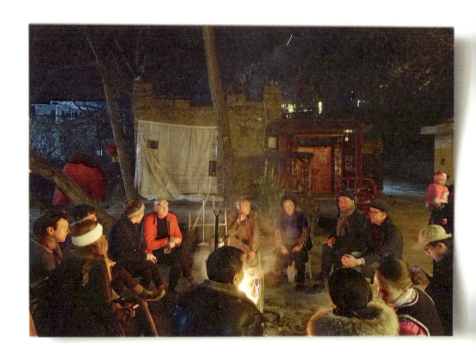

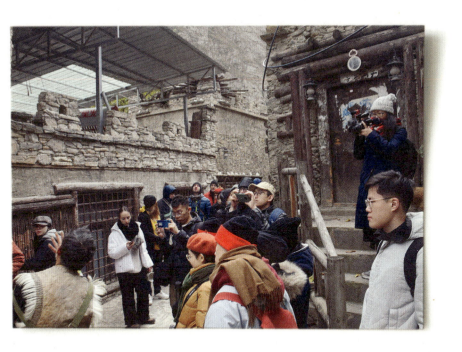

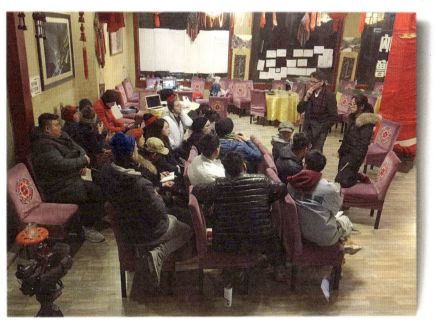

产中的有机物循环利用，以漫画书的方式探讨了永续农业的在地实施；而另一位年轻的导师则从时间的维度，针对汶川大地震之后龙舌兰种植在乡村周边自然生态恢复过程中的角色，做了细致而精美的全景式图示。

传统的价值——民间手艺在大多数时间总是处于隐匿的状态，出于好奇心理，一位学生发现了村落中围绕木制门锁的空间防御关系，发掘了制作木锁的工匠，并通过邀请他进行手工制作表演，重新唤起乡亲邻里对他作为匠人的尊敬；另一位学生因为难耐此时此地的寒冷，就近搜寻能够找到的材料，以其家乡的传统做法搭建了临时的桑拿房，既满足了自己对温暖的需要，也为场地居民展示了来自异国他乡的营建智慧。

日常的美感——美感是智慧的一种外化方式，日常生活里的各种片段，通过端详、理解和诠释，均可被视作某种自然而然的美。一组学生在貌似无所事事的村中漫游中，收集整理各种动植物片段、生活用品和家具农具等，将其进行重新组合与编排，并拼贴构成一场"短瞬"的展览，进而将村落中空置的戏楼转化为具有思辨性的"不真博物馆"；一位导师则受到"杀年猪"活动气氛的感染，观察感受其全过程的仪式，类似歌剧的节奏，用图画的方式将生活场景的美强调出来，并借此引发大家围绕"杀生与节庆"话题的热烈讨论。

废物的价值——物质价值的体现很大程度上关乎它们被发现、被生产的机缘，一位学生关注村落家庭中的由无用的废弃物料制作的椅子和坐凳，探究其如何被制作、被完善、被改装和被使用的过程，从中探讨材料、工艺、用途的物质价值及其背后所涉及的文化传统、家族亲情关系和情感记忆等的精神价值；另一位同学则发现村落附近荒野中被忽略的"石渣"竟是她所在国家文化中的某种"宝石"，并以此为线索展示她的"重大发现"，利用"石渣"制作了优雅的项链，表达对被忽视的自然价值的唤醒。

沟通与叙事——信息调查和成果表述，不仅是作为学术研究的手段与流程，很多时候更能成为对现场对象的某种介入，这种互动关系集中表现为媒介和方法的角色。一位学生擅长于入户拉家常式的采访，将抽象的家庭关系、居住生活及空间环境作戏剧场景化的述说，而在她以视频拍摄、编辑与回放给被访者的过程中，既融合了双方的关系，又唤起了各自对家庭的重新理解；另一位导师则以其一直研究和实行的"述行绘图"方法，用手绘素描的方法和立体地图的艺术形式，尽可能地收录观察对象和与对象交流所获得的信息，并在绘图的过程中及其后鼓励村民参与评说，以达成对绘画作品本身及村民集体意识与记忆的动态建构。

真伪之辨 从现场调研工作的第一天开始，所有的参与者都特别关注"真伪"的话题，其中涉及"场地对象是自然村落的身份，或只是乡村旅游景点的典型个案？""短期的调研是否会流于走马观花的形式？""之前对乡村图景的想象与期待，对比现实中所感受到的，哪一个更真实？""严谨专业性的研究成果，对比貌似儿戏般的艺术表达，哪一个更有真正的价值？"诸如此类的话题一直伴随着工作坊及后续展览的过程，其内涵涉及从宏观到微观，从过去、现在到未来，多层面、多维度深入探讨人与人，技术工艺与自然生态之间的复杂关系；也涉及我们人类所处的时空系统中，作为个体的人与

其他物种之间如何共存的深刻命题，思考人与其所处世界的一切他者持续变化中的关系。国家地区、政治文化、生活方式、教育背景、专业学术目标的差异，甚或个人性格的多样性都会影响看待、思考和回答这些问题的角度、理据和表述方式。

这个时代中的思想、情感、物质与图像永远处于流动状态，在科技高度发达的当下，我们理解世界的方式不再拘泥于单一、稳定的源头，世界本身也是在不断的混合、交换与沟通中持续生成的。这种新的"交融"使得所有的知识生产都在跨领域的维度中诞生，所有的感知都依赖于复杂的网络才能得以生效，所有的存在都是复合和多重维度的。作为国际学术交流，我们不强求得出一致的看法，倒是很乐于将其以作品并置的方式呈现出来，从"城市和乡村对照"的视角、观看的"时态"、强调"本土"现实意义的视线，到"多重现实、共时存在"，始终希望在推动包容、拓宽研究视野向度的同时，激发和呈现出思想的持续碰撞。

四个展览两次巡游 由于2019年深港城市建筑双城双年展（深圳）在前期策划和后期展览的安排过程中，出现了多次的调整与改变，我们原来设想的成果展示方式也受到一定的影响。

因为这其中的变故，使我们全体重新认识项目工作的主旨与意义，将原本的一次最终展览拆解成四个展览环节，在工作坊及后续工作过程中：

我们在羌族村寨就地取材、利用场院搭建简易展场，邀请村民参加集会式的总结交流，大家结队，一起手举家具、农具等具有当地代表性的物件绕村巡游，以激发工作坊成员和村民对村落场景的情感抒发。

在深圳雕塑院所在的街区我们邀请了醒狮团队一起联欢，在庆祝工作坊圆满结束的同时，再次以广东特色的巡游方式与周边商铺店主、顾客进行互动，使原本被市政施工影响的生意情境得以暂时性地恢复。

在深港城市建筑双城双年展福田车站主展场被压缩得极为局促的展位里，我们以多屏方式循环播放编辑制作后的作品视频，并摆设了从现场带回的水果、各式生产生活用具和坐凳，营造了亲切、动人的沉浸式体验，也为观众提供了短暂歇息和耐心观看体会的可能。后续在广州美术学院建筑设计学院的宽阔展厅中，我们以更生动多样、转化重现的手法，创造了一个趣味性与学术性高度融合的汇报展览，部分陈列内容至今仍然保存在展厅里，为后续师生反复观看学习保存了一条延续的线索。

奥地利林茨艺术大学因受疫情影响，未能在其学院画廊现场展出，但利用网络做了线上展示与交流传播，并率先编辑出版了收录双方成果的学术书籍。

这一系列通过视角、场域、媒介等的转换，激发和引导研究者、创作者和观众的思考与表达的组合尝试，共同反复演绎了乡村的智慧。

作为2019年第八届深港城市建筑双城双年展（深圳）"城市之眼"主展区的参展项目，我们希望把本项目的研究工作当成一面镜子，透过其阶段性成果的呈现，与其他团队项目的当下城市生活面貌记录和面向未来的畅想共置一处，并形成对照，引发人们对"人工生态"概念的重新思考和全面理解。在"人工生态"单元中，因主题及其导向的

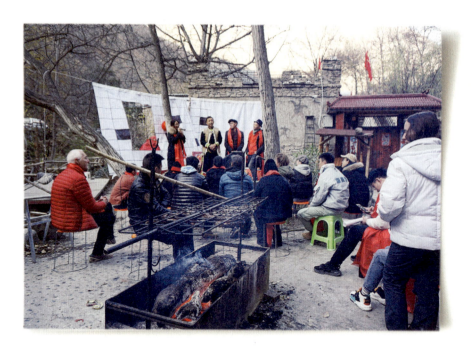

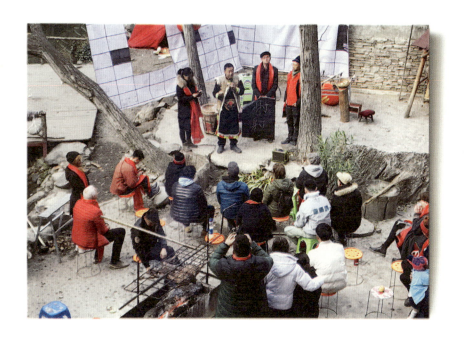

原因，大多数展品都是以城市和建筑为对象，也都倾向于探讨技术、面向未来，我们展出的成果作品刚好相反，选择乡村为对象，讨论自然和人类关系，并试图以回溯的方式来表达我们对人与自然、人与人造物、传统与当下的观察、感悟、思辨以及对未来发展的态度。

对工作坊成果的共同整理与编辑，在2020年初新冠病毒肺炎疫情暴发后，成为我们两校团队连接彼此的一种特殊方式，借此得以梳理热情动人的共同工作回忆，又尝试从中脱离出来，回到各自独立的思辨立场和角度，将现场的信息加以解构和重构，将"此曾在"的内涵及其特质与我们的"现在"加以互动及拓展。

在工作坊过程中，不同文化和专业背景的老师、学生、当地居民以他们各自的方式，呈现了今天人与人、人与非人之间关系的不同方式。这本书不仅是一份当时的记录，更是鼓舞我们在专业学习和研究中，重组时空线索，调整并打破自我与社会现场间边界的醒示。

我们以发现与演绎的方式审视传统的自然村庄，将其视为可供重新诠释并融入当代城市生活方式的元素来源。我们可以尝试突破怀旧或保守的态度，抱着善意去改变自然环境的现状，而对乡村生活的理解经过深度持续的发酵，一定会为我们的城市未来带来新的启示和活力。

我们更希望能在此基础上，进一步强化我们对相关课题的认识和学术研究的深度，并持续丰富和提升我们自身在研究及创作中的情感与智慧。

杨一丁

The world is not only urban, but also rural. Urban living conditions are very modern and rich, and are also popular with young people. However, as an important support for urban life, rural areas provide food, protect nature, and breed a large number of labor forces, which provide necessary guarantee for modern life.

Although the countryside will continue to exist, with the transformation of the rural life system, the wisdom contained in the way of life, technology, economy, culture and other aspects is considered outdated thus being ignored and forgotten, which is a huge waste of civilization from the perspective of historical heritage significance and practical application value.

In this Smart Village workshop, we need to observe specific natural phenomena entirely, and also understand the relationship between nature and human life consciously. In this process, we tried to get rid of the inherent stereotypes, start from a proposition boldly hypothesis, based on each's own knowledge background, use logical rules to verify seriously, through speculation and discussion in group communication, reasonable and imaginative extension and expression. This is not only to collect records, but also to learn and inherit previous experience, as well as helps to derive new propositions and enhance innovation ability.

Project cause

Project cause Guangzhou Academy of Fine Arts and University of Art and Design Linz have a long-term teaching cooperation, including accept exchange students at undergraduate and postgraduate level from both sides, which shows a close academic relationship between them.

Ms. Zheng Xian, one of the initiators and organizers of this workshop, during

master's degree in The School of Architecture and Applied Arts of Guangzhou Academy of Fine Arts, she studied in University of Art and Design Linz as an exchange student, and then continue studied for her doctoral degree in the Department of Spatial Strategy. She participated and organized group projects and related activities at the 2015 and 2017 Shenzhen Urban Architecture Biennale. She did a lot of liaison work for the academic exchanges between the two schools, and made a lot of preparation for the preliminary planning and achievement demonstration scheme of this activity.

The School of Architecture and Art of Guangzhou Academy of Fine Arts also invited Rianne Makkink and Ton Matton, two professors of University of Art and Design Linz in this workshop, to give special academic lectures. During the exchange activities, they deeply recognized each other's research and teaching work, and expressed their willingness and expectation to carry out cooperative research teaching activities for many times.

In late 2018, planned together by related disciplines between our two universities, Qiang village in Wenchuan, Sichuan province was chosen as the object, to carry out international cooperation and research academic exchanges, and proposed to exhibit in the results of the project workshop of UABB in 2019.The project plan was approved and supported by the two schools and organizing committee of Bi-city Biennale of Urban\Architecture, Shenzhen and Hongkong(UABB), after contacting and preparation before the start, the project officially launched in November 2019.

Activities "Smart Village·Discovery and Interpretation — Wenchuan Qiang Valley Workshop" by The School of Architecture and Art Design, Guangzhou Academy of Fine Arts, China (3 teachers and 9 postgraduate students) and the Department of Spatial Strategy, University of Art and Design Linz, Austria (4 teachers, 10 graduate students), with Rianne Makkink, former professor of University of Art and Design Linz, as the invited academic advisor.

November 25, 2019. Workshop members visited the main exhibition area in Futian, Shenzhen.

November 26-27, 2019. At the beginning of the workshop, all members carried out academic lectures titled "Yang Yiding: Design · Relationship", "Rianne Makkink: Industrial Cultural Landscape Practice", "Josef Maier: Object Work" and "Zheng Xian: Deductive Painting", to understand the research ideas and characteristics between two uni, as well as to prepare for the workshop inspection stage.

During the workshop, all the members went to Wenchuan, Sichuan province and stayed in Dongmen Village (Qiang Valley) for a ten-day investigation. At the end of the inspection, a live exhibition was held in Dongmen Village. At the winter Solstice, workshop members and villagers held a party and festival parade together.

October 10-December 13,2019 The workshop used the space of Shenzhen Sculpture Academy to summarize and organize the investigation works, edited and produced corresponding video results, and held lion dance and parade activities in surrounding communities at the end of the workshop.

December 20-22, 2019. Workshop results are arranged and opened in Shenzhen Double Exhibition.

December 23-27, 2019. Preparation and arrangement of the workshop results exhibition in Guangzhou Academy of Fine Arts, officially launched on 27th.

May, 2020. Due to the pandemic of COVID-19, the results of the workshop are

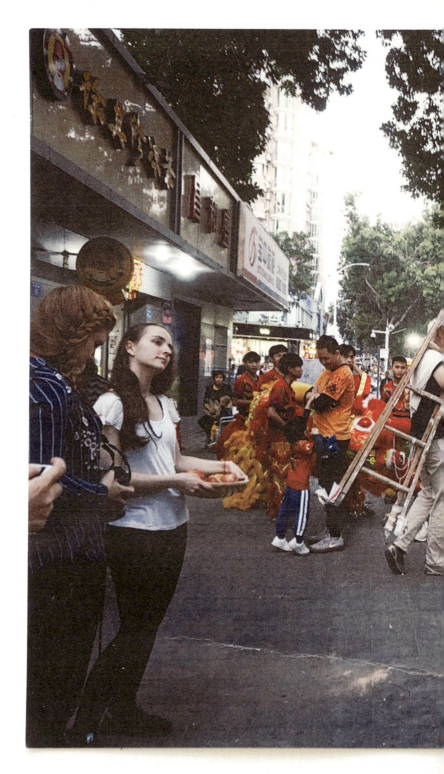

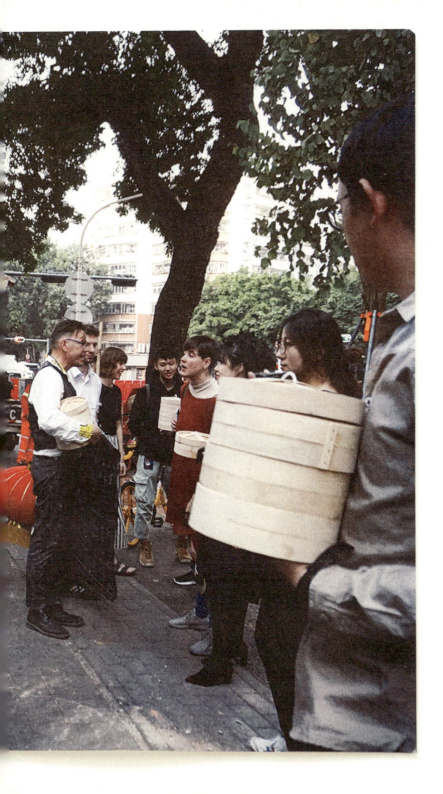

displayed online at the University of Art and Design Linz, Austria.

The research contents During the international workshop "Smart Village" , teachers and graduate students from two universities, respectively for space facilities build, crop production and sales, household life and social, traditional appliance manufacture, totem worship, water conservancy facilities system, festival celebration and soil protection to carry out the research, and combined with their own professional background and academic interests, completed their own achievements and works, they are not only distinctive, but also intertwined with other works into a number of follow-up in-depth research and discussion clues.

It is interesting that the cooperation in the workshop is not mixed Chinese and foreign students into teams as usual, and then accomplished their research under the guidance from both Chinese and foreign tutors, but is based on academic background, discovered by the unique problems of site, combined freely and finished their relatively independent investigation and research, in various stages of the process nodes through the discussion of contrast to find people with similar values as well as build a relationship of mutual help and cooperation on the premise of mutual appreciation. In addition, the tutors are not only served as mentors, but also made observations and explorations that reflected personal interests and thoughts while organizing and guiding.

Interesting contrast

Existing Graphics – there are many houses in the village with all kinds of totems and hieroglyphic symbols, its semantic may not clear, perhaps just because of the need of beautification, a group of students used the these patterns as a virtual language, by attempting to plot with the villagers, built up their expansion understanding and combined expression on the painting stones; While another students was interested in the slogans in the village, trying to sort out the consistency and contrast between their appearances and connotations, so as to understand the multi-level sense of human existence in the village.

System and Informal – An important measure of rural construction is to improve the conditions of infrastructures. A group of students paid attention to the various states of water in the village and the three-dimensional network system formed by them. They made spatial diagrams and captured the existing problems, and completed the professional graphical results. While a tutor was more interested in various implementation details in the village construction system, observed and collected a series of "informal" fragments that reflect the wisdom of life, and making interesting image comparisons with classic works of contemporary art and design to reveal the common logic behind independent details.

Three Dimensions of Agricultural Production – agricultural production is one of the core values of rural existence, its process and form raises various exploration, a group of students started from had eaten a sweet apple, by investigating production, transportation and sales process of the local apples, understood multidirectional information like the geographical climate, way of working and family production organization, the value of online-sale. In addition to research, he became an enthusiastic salesman. An older student focused on the recycling of organic matter in agriculture, using comic books to explore the practicability of sustainable agriculture. Another young tutor made a detailed panoramic illustration in time dimension, on the

what role did agaves cultivation play in the restoration of natural ecology around the countryside after the earthquake, which took place in Wenchuan, 2008.

Value of Tradition - Folk crafts are always under a hidden condition. Due to curiosity, a student discovered the spatial defense relationship around wooden locks in the village, discovered the craftsman who made wooden locks, and invited him to give a handmade performance to arouse the respect of his neighbors for him as a craftsman. Another student, unable to stand in the cold weather, searched for materials nearby and built a temporary sauna in the traditional way of his hometown, which not only satisfied his own need for warmth, but also showed the construction wisdom of the site residents from a foreign land.

The Beauty of Daily Life - Beauty is an externalization of wisdom, fragments of everyday life can be viewed, understood, and interpreted as a kind of natural beauty. A group of students seemed idle roaming around the village, collecting and sorting out various animals and plant fragments, articles of daily use, furniture and farm tools, etc., and then recombined and arranged what they had obtained, and collaged them to form an exhibition, so as to transform the empty theatre building in the village into a thinking "unreal museum". A tutor was affected by the atmosphere of the "killing pig" activity, observed and felt the whole process of the ceremony, compared it to the rhythm of operas, emphasized the beauty of the life scene with pictures, and thus triggered a heated discussion around the topic of "killing and celebrating".

The Value of Waste - the value of materials is largely related to the chance of being discovered and produced. A student focuses on the chairs and benches made of useless waste materials in a village family, and explored how they were made, improved, modified and used, from which cultural tradition, families relationship and memories behind materials, crafts and functions were discussed; Another student found that the neglected "stone residue" in the wilderness near the village is a kind of "gem" in the culture of her country. Taking this as the theme, she used it to make an elegant necklace to show her "great discovery" and to express the awakening of the forgotten natural value.

Communication and Narration - information investigating and achievement expressing are not only the methods and process of academic research, but also a way of involving objects in many cases. This interactive relationship is expressed as the role of media and methods. A student who is good at home style interviews, described abstract family relations, living and space environment in dramatic scenes. In the process of video shooting, editing and playback to the interviewees, she not only integrated the relationship between the two sides, but also arouses their new understanding of the family. Another teacher used "performative drawing", the way she has researched and practiced for long time in the art form of sketches and cubic maps, observed objects as much as possible and communicated obtained information with the objects, encouraged villagers to participate in the process of drawing, so as to achieve the painting itself and the dynamic construction of the villagers' collective consciousness and memory.

Debates on Real and Fake From the first day of site research, all participants paid special attention to the topic of "authenticity", which content "Is the site objects the identity of natural villages, or is it just a typical case of rural tourist attractions?" "Will short-term research become more of a cursory exercise?" "Which is more real,

my imagination and expectation of the rural landscape, or what I feel in reality?"
"Which is more valuable, a rigorous and professional research result, or a playful artistic expression?" Such topics has been accompanied by the workshop and the subsequent exhibition process, its content involves from macro to micro, from the past, now to future, from multi-level to multi-dimensional, inquired into people, technology, the complicated relations between natural ecology, also we humans in space and time system, as a topic of how individual person coexistence with other spices, considering the ever-changing relationship between man and all others in his world. Differences in countries, regions, political cultures, lifestyles, educational backgrounds, professional and academic goals, or even the diversity of individual personalities will affect the perspective, rationale and expression of viewing, thinking and answering these questions.

In this era, thoughts, emotions, materials and images are always in a state of flow. At present, with highly developed science and technology, our way of understanding the world is no longer confined to a single and stable source, and the world itself is constantly generating in nonstop mixing, exchange and communication. This new "blending" enables all knowledge production to be born in a cross-domain dimension, all perceptions to be effective in complex networks, and all beings to be complex and multi-dimensional. As an international academic exchange, we are not importuning to reach a consistent view, but more likely to be happy to express our works in the way of juxtaposing them, from the perspective of "urban and rural contrast" watch "tense", emphasize "indigenous" the practical significance of the line of sight, to the "multiple reality, synchronic existence", we always hope to promote tolerance and broaden the research field of vision direction at the same time, inspire and present a constant collision of ideas.

Four Exhibitions and Two Tours Due to many adjustments and changes in the preliminary planning and later exhibition arrangements of the 2019 Shenzhen Urban Architecture Biennale, our original way of exhibition was also affected to some extent.

Because of these changes, all of us had a new understanding of the purport and significance of the project work. The original final exhibition was divided into four exhibition stages. In the workshops and follow-up work:

We used local materials and set up a simple exhibition hall in Qiang village. Villagers were invited to participate in a gathering of summary and exchanging, and they walked around the village in groups holding local representative objects such as furniture and farm tools to stimulate the workshop members and villagers to express their feelings about the village scene.

In the block where Shenzhen Sculpture Institute is located, we invited the Lion Dance team to have a party together. While celebrating the successful completion of the workshop, we once again interacted with the shop owners and customers in the surrounding area in a parade with Guangdong features, which temporarily restored the business situation which had been affected by the municipal construction.

In deep double exhibition, the station master show be compressed very cramped in the booth, we produce works after screen mode looping edit video, and decoration from the scene back to fruits, all kinds of production and living appliances and stool, build a warm and moving immersive experience, also gives the audience a brief

rest and patience to watch.

Later, in the wide exhibition hall of the School of Architecture and Design of Guangzhou Academy of Fine Arts, we created an interesting and academic report exhibition with vivid and diverse methods of transformation and reproduction. Part of the display contents are still preserved in the exhibition hall, which is a continuing clue for subsequent teachers and students to repeatedly watch and learn.

University of Art and Design Linz, Austria was unable to exhibit in its college gallery due to the impact of the epidemic. However, it used the Internet to make online exhibitions for communication and dissemination, and took the lead in editing and publishing academic books containing the achievements of both sides.

This series of attempts to stimulate and guide the thinking and expression of researchers, creators and audiences through the transformation of perspectives, fields and media have repeatedly interpreted the wisdom of the countryside.

As the project in the main exhibition area "eye of the city" in the eighth UABB, 2019, we hope to work in the project as a mirror, through its achievements in the present, with the rest of the team projects of current urban life records and for the future and think about to buy a contrast, it will lead to a rethinking and comprehensive understanding of the concept of 'artificial ecology'." In the unit of artificial Ecology, due to its theme and orientation, most of the exhibits are targeted at cities and architecture, and tend to discuss technology and the future. Our works are just the opposite. We choose the countryside as the object, discuss the relationship between nature and human, and try to use it as a contrast to the city. Through retrospection, we express our observation, perception and speculation on man and nature, man and man's creation, tradition and present, as well as our attitude towards future development.

Editing the workshop results together, became a special way to connect each other between our two universities in the early 2020 since corona virus pneumonia outbroke, we were able to comb work enthusiasm and touching memories, but also tried to get rid of them at the same time, thus to return to the position and perspective of each one's. The connotation and characteristics of "once here" are interacted and expanded with our "now".

This book is also a record of how people, people and non-people are connected in different ways, reorganizing the spatial and temporal clues, adjusting and breaking the boundaries between self and social scene, presented by teachers, students and local residents with different cultural and professional backgrounds in their own ways in the workshop process.

We examined the traditional natural village through discovery and deduction as a source of elements that reinterpret and integrate into the contemporary urban lifestyle. We can try to break out of nostalgia or conservative attitudes and change the status quo of the natural environment with good intentions, while understanding rural life can enable us to bring new environmental inspiration and vitality to the future of the city.

On this basis, we hope to further enhance our understanding on relevant topics and the depth of academic research, and continue to enrich and enhance our own feelings and wisdom in research and creation.

Yang Yiding

行与思的方法

Methods of Action and Thoughts

I–II

行与思的方法
Methods of Action and Thoughts

教学的媒介 如何引发两校学生思想上的交流，让工作坊的成员真正合作起来？两校学生在知识背景、个性和创作目的上都有很大不同：林茨的学生是学习艺术的，他们善于捕捉场所的特征，通过作品来表达个人观点，思考基于直觉和感受；广州美术学院的学生是学习设计的，他们更关注事物的来龙去脉，通过设计来解决问题，思考基于系统性和发现。最终，通过创作方向的认同，学生们产生了合作，两种不同的思维方式在工作坊中得到了融合，并通过艺术创作和设计营造等形式进行表达。然而，这种融合并非自然发生的，而是通过一系列教学媒介引导而来的。本次工作坊所采用的不同形式的教学媒介有：启发性的物件、概括性的绘画、多元化的讨论等，这些媒介引导的思维交流路径清晰而开放，为学生们提供了一个信息宝库。

启发性的物件： 在场地调研的过程中，大家边走边收集两件自己认为最能代表自己对
pic.1-1 场地感受的物件。晚上开展讨论会，学生们围成一圈，把物件集中放在中间的地面，开始分享自己对场地的认知。分享者拿起自己的物件，为大家解说，分享者结束后，要指定下一位分享者，并把自己的物件放置在与自己物件能产生联系的物件旁边，并解释原因。这些物件能让大家的表达言之有物，并能直接激发他人的思考，进而产生交流。Rianne在场地中收集了一些石头，这些石头勾起了她儿时的回忆，这些石头和荷兰当地的一种"穷人的钻石"是同一种石头，是她小时候在乡村玩耍时用来做项链的材料，郑娴补充说，这种石头其实就是当地的一种矿物原料；王海鸥在场地中发现了一种植物叶子，她小时候会用这种叶子来吹出声音，这种玩耍的方式引发了Toby的共鸣，他小时候也喜欢吹叶子的游戏，但所用的叶子并不是同一种。

概括性的绘画： 为了帮助大家明确想法，学生们把自己的项目方向和需要的他人帮助用简
pic.1-2 单的文字概括，并结合图解语言表达在一张A4纸。这个方法看似简单，但却很好地让学生梳理了自己的想法，凝聚成一个可以被阅读的画面，并在讨论会结束之后成为学生们进一步交流合作的起点。其中，Toby的手稿中提到想要和中国学生合作创作一个作品，也提到了龚博维的想法和自己想法的契合点；而Cory和黄辉、陈桂玲都关注到了石头和图腾文化，并在后续的项目中展开了合作；Jana和续晓雪、张沛彦都提到想要在村落的某个空间中组织一次"事件"，而他们也在工作坊中完成了这个目标。

多元化的讨论： 不同的讨论方式为学生们的项目推进提供了多元化的角度。圆圈会议
pic.1-3 是一种没有中心的教学讨论形式，大家围坐成一个圆圈，每个人都处于平等的状态，每个人都能看到表达观点的人。餐桌上也是大家讨论的好场所，日常就餐的圆桌
pic.1-4 约8人一桌，每次就餐同学们都会交替穿插在不同的餐桌中，以达到不同的信息交流。话题的辩论则能迅速催生出可供思辨的观点，Ton带领大家展开了一场关于村落
pic.1-5 里所呈现的"假"的状态的辩论，同学们各抒己见，讨论"真与假"在村落的发展中所带来的意义的变化。小组讨论是工作坊和教学中最常见的教学方法，由于工作坊大家全天都在一起，所以小组讨论是随时发生的，尤其是在项目场地上的讨论，是

pic.I-1 pic.I-2
 pic.I-3
 pic.I-4

pic.1-6 更直接和深入的。在场地中的公开评图能让人产生深刻的体验，评图的意义不仅仅停留在团队内部的层面，更是一次与当地村民、周边居民交流的机会。

参与的行为 如何与当地人展开交流，能寻找到设计研究的信息和创作的线索？如何能更好地体现在场地中做创作的价值？当代的农村，尤其是像东门寨这样的农村，与外界交流是频繁的，这里有农家乐和旅店，有水果种植和售卖，有去城里打工的家庭，有便捷的手机和互联网，虽然语言存在口音上的不同，但交流是没有障碍的，生活方式也和城市没有本质的不同。在近乎与城市同质的环境里，乡村的生活仍然令人感到好奇，同学们尝试用不同的行为方式与村民交流：语言的表达、视觉的交流、身体的参与等，在这些参与其中的行为中，丰富的感官刺激比网络信息能够带来更多的启发。而对于村民，我们带来的除了经济效益以外，还有记忆与生活中新的跨地域的联系。

语言的表达：语言的交流是最直接和便利的。村中的"二把手"唐叔用羌族普通话向
pic.1-7 大家系统性地介绍了村子的情况，为学生们提供了发现的第一条线索。与唐叔交流，和与村民们交流一样，他们的方言普通话口音很重，再加上我们需要进行英语翻译，英语又进一步转化成德语，因此存在一定的信息流失，并不能达到完整和精确的交流。但是，语言的交流仍然是最便利的，唐叔的东门寨导览介绍与村民们随机发生的对话和询问，针对某一话题展开的项目访谈及深入交流等，都为项目的推进提供了最直接的信息源泉。邱健敏发现村民在冬天都喜欢围着火炉交谈，因此她走进了不同
pic.1-8 村民的家，围坐在火炉前对村民展开了访谈，并用影像记录下了这个乡村日常的
pic.1-9 场景。在访谈中，邱健敏穿着羌族服装，服装本身是一个交流的话题，也是拍摄画面中的一个重点，串联了所有的访谈。

视觉的交流：图像是一种视觉的交流语言，而绘画的过程也会以行为激发语言的交流，使得两个陌生人拥有了直接交流的介质，人们会为绘画的方式和目的展开讨论，进而打开更多的话题。带着孩子们画画，能根据绘画的内容与孩子们展开详细讨论，如兴趣爱好、生活习惯等，是对当地生活了解的一种不同形式。Jana 的方法很特别，她
pic.1-10 用拓画的方法，在寒冷的冬天，为孩子们带来了一场运动的绘画课，孩子们能快速进入状态，并对这种别样的绘画方式很感兴趣。郑娴站在河边绘画，路过的村民与
pic.1-11 她产生了交流，村民询问绘画场景的相关内容，当村民看到绘制的是自己的房屋时会产生很大的兴趣，绘画的行为拉近了人与人之间的距离，而交流的内容也能反过来引导绘画的表达。陈桂玲、黄辉和 Cory 带在河边收集的不同大小的鹅卵石，和一
pic.1-12 张印着他们在村里拍下的各种图腾的 A4 纸，与村民进行了与平常调研不同的交流。交流围绕纸上的图腾展开，让村民们说出自己对图腾的理解和相关的故事，并用蜡笔在石头上绘制自己喜欢的图腾，这些图腾经过村民之手被赋予了新的意义。

身体的参与：好奇心使大家用身体参与到研究的内容之中，这种方式能最直接地了解到事物的源起和发展，也能在体验中激发个人的思考。王海鸥发现被加工后的凳子是村民坐在火炉边的交流道具，这些凳子的顶部用枕头或软布包着，以增加其舒适度，适应长时间烤火、聊天的行为。为了更好地记录下这种智慧，王海鸥购买了与原来凳子相似的新

pic.I-6 pic.I-5
pic.I-7 pic.I-8
pic.I-10 pic.I-9

pic.I-13 材料，与村民共同制作了新凳子。潘泓和林梓晟对当地人种植苹果的日常生活产
pic.I-14 生了好奇，他们跟随着果农上山摘苹果、下山卖苹果，记录下果农一天的生活，
并通过自己的手机社交软件和后续学术展览等方式对苹果的售卖进行了推广。Jana对
pic.I-15 羌族服装中的刺绣产生了兴趣，她在边制作鞋垫刺绣边和邻居聊天的阿姨旁坐下
仔细观察，并动手尝试学习刺绣。在工作坊的最后一天夜晚，村民在村里的小池塘边点
pic.I-16 起了篝火，载歌载舞，庆祝他们民族的传统节日，来自异乡的工作坊师生也随着
音乐的节奏，加入舞蹈的队伍，翩翩起舞，很自然地融入了村落喜庆气氛之中。

在地的表达 如何在一个乡村环境中表达自己的发现和观点，是适合这个环境、适合"智慧乡村"这个主题的？这次工作坊的第一期成果制作、展示都在村里，能最直接地表达在乡村的发现：村民的生活方式、村民的劳动方式、村民的思想交流、村里的物件、村里的环境体验……大家尝试用不同的方式来呈现自己的发现：影像制作，用影像直接记录所见所闻；场所营造，在村落合适的场地中用当地发现的材料赋予场地新的意义；实物制作，与当地人的合作制作所研究的物件；事件组织，让学生、老师和村民一起参与到创作之中；展览由展厅到现场，又由现场到展场的置换，以巧妙的方式在不同时空下呈现多维度的展览内容。这些表达方式都以不同的角度回应了在地性的表达，让艺术创作和设计思考回归到场地各自独特的条件属性之下，产生了独特的表现力与感染力。

影像制作：对于村民的生活与交流最具有叙事性的记录方式是影像。影像拍摄具有场景
pic.I-17 性，能把空间、行为、内容和声音都记录下来，在有限的时间内是很好的记录方式，也是最直接的表达方式。邱健敏用影像记录下了她与村民有关"火炉与手机"话题的访谈，也记录下了不同的家庭空间、火炉的类型和对于传统和当代生活的感受。潘泓和林梓晟记录了苹果种植户一天劳作和销售的生活，用影像揭示了有关苹果的诸多细节。

场所营造：在陌生的村落中，用身体感知环境的独特性，用当地发现的材料和方式来营造空间，并最终让身体参与到作品的完成过程中。Toby的作品《桑拿》是对村落寒冷
pic.I-18 环境的一个直接回应，他结合了自己儿时对欧洲传统桑拿空间的认知，并通过建造活动在村落环境中营造了一个温暖的场所，也在整个过程中治疗了自己的感冒，身体获得与场地的新联系。Jana、续晓雪和张沛彦的乡村博物馆收集了村落中闲置、废
pic.I-19 旧、丢弃的物件，并找到村落中闲置的文化活动室，进行组合展示，使一个被废弃的文化活动站变身为既本土又当代的文化博物馆。Christian利用餐厅的椅子和一个
pic.I-20 狭小的房间，搭建了简易的剧场并为大家表演了欧洲童话木偶剧。

实物制作：实物制作能直观地呈现与体验村落中发现的特殊物件及其背后文化内涵。龚
pic.I-21 博维请当地的一位木匠师傅制作了传统的木锁，并记录下整个制作过程的细节，木锁实物引发了大家对于传统防御系统的兴趣，在亲身体验开锁乐趣的同时，也更理解了其中无法言说的奥妙。王海鸥通过和村民一起制作新凳子，以新换旧，获得了旧凳子作为实物展品，而参与制作的经历也是收集研究乡村智慧的捷径。

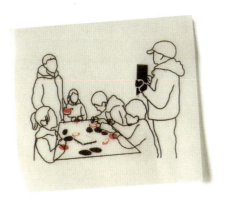
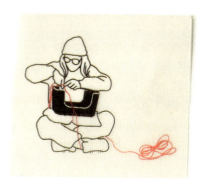
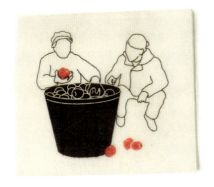
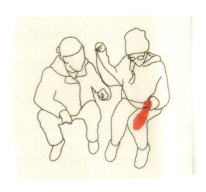

pic.I-11 pic.I-12
pic.I-13 pic.I-14
pic.I-15

事件组织：组织一场活动，能引发村民、参与者强烈的参与感。陈桂玲、黄辉、Cory组织了一场村民参与的石头绘画活动，故事、绘画、石头融合，共同完成了多层信息叠印的成果。Jana、续晓雪和张沛彦的乡村博物馆开幕剪彩活动也是一个仪式感极强、提升观众参与度的活动；展览过程中还进行了创作诗歌朗诵，将作品所包含的信息情景化地传递出来；最后，工作坊成员和村民代表各自选取一件自己感兴趣的物品，携

pic.I-22 着这些物品道具在村里巡游，走了一圈之后，又把物品放回了它们原来所在的场地，那个博物馆也重回空旷，整个过程充满了事件性和戏剧性。在深圳，展览开幕的当日，为了筹办展览开幕的美食派对，大家伴随着舞狮表演，举着各自找来的容器，结队到附近的餐厅购买食物，往返过程构成了与乡村巡游对应的都市巡游。

展览置换：在2019年深港城市建筑双城双年展（以下简称"深双展"）的特殊性下，催生了这次"展览置换"的想法。把深双展厅原型按1：1在村里搭建，并在这个展厅中举办活动，用影像记录，最终展示在深双展现场。考虑到便利性与对场地影响的最

pic.I-23 小化，搭建方式选择了非正规的解决方案，利用了场地中的树、石头和在集市中购买到的绳子，让"展厅"在村落中心的小平台处构成了一个公共的"背景"，在这个"展厅"中，举行了"杀年猪"、煮硫磺、篝火晚会、烤全羊、闭幕仪式等。在深圳雕塑院、深双展厅对"最初的设计"进行了大幅度的压缩与转化，并通过视频和实物展示，生动地传达了这次工作坊期间两校学生和老师在遥远的羌族村落所发现的乡村智慧。

温颖华

The Medium of Teaching How to trigger the exchange of ideas between the students of the two schools, so that the students of the two schools could really cooperate? There are great differences in the knowledge background, personality and creative purpose of students from the two universities. Students in Linz study art, and they are good at capturing the characteristics of the place, emphasizing the expression of personal opinions through works, thinking based on intuition and feelings. Students of GAFA study design, they pay more attention to the ins and outs of things, solve problems through design, and think based on system and discovery. Finally, by agreeing on the direction of creation, students from the two universities cooperated. The two different ways of thinking were integrated in the workshop and expressed through artistic creation and space creation. However, such integration does not occur naturally, but is guided through a series of teaching media. The different forms of teaching media used in this workshop include illuminating objects, general paintings, and diverse discussions. These medium lead to clear and open communication paths, providing students with a treasure trove of information.

Objects: *In the process of site research, everyone collected two objects that they* pic.I-1 *think best represent their feeling about the site.* In the evening, students gathered in a circle, placed objects on the ground in the middle, and began to share their knowledge of the site. Sharers pick up their own objects, explain to everyone, the next sharer will be appointed by the previous sharer, and the next sharer then

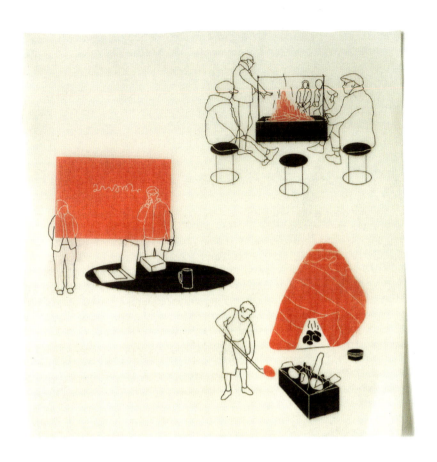
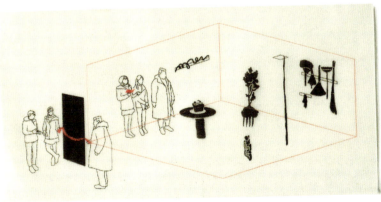

pic.I-16
pic.I-17
pic.I-18
pic.I-19

put his object next to the object that can connect with, and explain why. These objects give meaning to people's expressions and directly inspire others to think and communicate. Rianne collected some stones in the field, and these stones brought back memories of her childhood. These stones are the same kind of stone as the "poor man's diamond" in Holland, which she used to make necklaces when playing in the countryside as a child. Zheng Xian tells us that this stone is actually a local mineral material. Wang Haiou found a plant leaf in the field, which she used to blow when she was a child, and this way of playing resonates with Toby. He also liked to play the game of blowing leaves when he was a child, but the leaves are not from the same plant.

Sketches: *To help clarify ideas, students summarized their project directions and* pic.I-2 *needed help in simple words, and expressed them in graphic language on a piece of A4 paper.* This seemingly simple method does a great job of getting students to sort out their ideas, condense them into a picture that can be read, and serve as a starting point for communication after the discussion. Among them, Toby's manuscript mentioned that he wants to cooperate with Chinese students to create a work, and also mentioned the convergence of Gong Bowei's and his own ideas. Cory, Huang Hui and Chen Guiling all paid attention to stone and totem culture, and launched cooperation in the follow-up project; Jana, Xu Xiaoxue and Zhang Peiyan all mentioned that they wanted to organize an event in a certain space, and they also completed a work together in the workshop.

Discussion: Different discussion methods provided students with different perspectives to help advance the project. *Circle meeting is a form of teaching* pic.I-3 *discussion without a center, where everyone sat in a circle, everyone is on an equal footing, and everyone could see the person expressing opinion. The dining* pic.I-4 *table was also a good place for discussion. There were about 8 people at a table for daily dinner, and students would intersperse at different tables to exchange different information.* On the other hand, the topic debates can quickly stimulate diversified viewpoints. Ton led us to launch a debate on the state of "fake" in pic.I-5 the village. *Students expressed their opinions and discussed the changes of meaning brought by "true and fake" in the development of the village.* Group discussion is the most common teaching method in workshops and teaching. pic.I-6 *Since everyone in the workshop was together all day long, group discussion can happen at any time, especially in the project site, it is more direct and in depth.* Public comments on the site can create a profound experience. The significance of comments is not only within the team, but also an opportunity to communicate with local villagers and surrounding residents.

The Act of Participation How to communicate with local people to find information on design and research and clues on creation? How to better reflect the value of creation in the site? Contemporary countryside, especially in rural areas, such as the Dongmenzhai village is communicating with the outside world frequently, there are agritainments and hotels, fruit cultivation and sales, families that member working in the city, and convenient mobile phones and the Internet, although different accents are existed, communication is no obstacle, the way of life have no difference with cities in nature, too. The environment that almost the same as cities, we were still curious about the life in this village. Students tried to communicate with the villagers

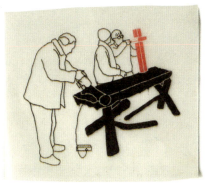

pic.I-20　　pic.I-21
pic.I-22

in different ways: verbal expression, visual communication, physical participation, etc. The rich sensory stimulation in these participating behaviors can bring more inspiration than the Internet information. For the villagers, in addition to the economic benefits, we brought memories and new trans-regional connections to their lives.

Communication: Language communication is the most direct and convenient. *Uncle Tang, the village's second-in-command, provided the students with the first clue* pic.I-7 *to their discovery by giving a systematic introduction to the village in Qiang Mandarin, which was the same as the communication with the villagers, they also spoke Mandarin with a strong accent.* In addition, we needed to translate from English to German, so there was a certain amount of information loss and the communication was not very accurate. However, language communication is still the most convenient. Uncle Tang's guide of Dongmen Village, random dialogues and inquiries with villagers, project interviews and in depth communication on a certain topic, all provided the most direct source of information for the project. *Qiu Jianmin found that villagers like to talk around the stove in winter, so she went to* pic.I-8 *different villagers' homes, sat around the stove and interviewed them, and recorded the daily scenes of the village with video. In the interview, Qiu Jianmin* pic.I-9 *wore Qiang costume. The costume itself is a topic of communication and also a key point in the shooting pictures, connecting all the interviews.*

Visual language: Image is a kind of visual communication language, and the process of painting will also stimulate language communication with behaviors, so that two strangers have a medium for communication, people will discuss the way and purpose of painting, and then open more topics. Take the children to draw, and discuss with them in detail according to the content of the drawing, such as interests and hobbies, living habits, etc., which is a different form of understanding of local life. *Jana's method was very special, she used the method of drawing,* pic.I-10 *in the cold winter, brought a moving painting class for the children, the children quickly got into the state, and they are very interested in this different* pic.I-11 *way of painting. When Zheng Xian stood by the river and painted, she had a conversation with a passing villager who asked about the contents of the painting scene.* When the villager saw that the painting was their own house, they became very interested. The behavior of painting narrowed the distance between people, and the content of communication could in turn promote the expression of painting. *Armed with pebbles of different sizes collected by the river and a sheet of A4 paper* pic.I-12 *printed with totems they took in the village, Chen, Huang and Cory engage in a different kind of communication with the villagers.* The exchange revolves around totems on paper, allowing villagers to tell their understanding of totems and related stories, and draw their favorite totems on stones with crayons. These totems were given new meanings after passing through the hands of villagers.

Participation: Curiosity enables people to participate in the research content with their bodies. This way can most directly understand the origin and development of things, and can also stimulate personal thinking in the experience. Wang Haiou found that the stools were a communication medium for villagers sitting by the fire. The tops of the stools were covered with pillows or soft cloth to increase their comfort and adapt to the behavior of warming themselves to the fire and chatting for a long time. *In order to better record this wisdom, Wang Haiou bought new* pic.I-13 *materials similar to the original stools and worked with the villagers to make*

pic.I-23

the new stools. Pan Hong and Lin Zicheng became curious about the daily life of local apple growers. *They followed farmers up the mountain to pick apples and* pic.I-14 *down the mountain to sell apples, recorded their daily life and promoted the sale of apples through their mobile phones and academic exhibitions.* Jana became interested in embroidery in Qiang clothing. *She sat down next to an aunt who was* pic.I-15 *embroidering with insoles and chatting, and learned embroidery by trying* pic.I-16 *her hand at it. On the last night of the workshop, the villagers lit a bonfire in the center of the village and celebrated their traditional festival with singing and dancing.* The foreigners also danced to the rhythm of music with the dancing team, which merged into the village customs.

Regional Expression How can I express my findings and opinions in a rural environment that is appropriate for this environment and the theme of "Smart Village" ? The production and display of the first phase of the workshop were all in the village, which can directly express the discovery in the village: villagers' way of life, villagers' way of work, villagers' exchange of ideas, objects in the village, environmental experience in the village... They tried to present their findings in different ways: video production, which directly recorded what they saw and heard; Place building, using locally found materials to give new meaning to the site at the appropriate site in the village; Physical production, cooperated with local people to make the object; Event organization, allowed students, teachers and villagers to participate in the creation; Exhibition displaced from exhibition halls to site, and back to exhibition halls again in an ingenious way. These expressions all respond to the expression of the locality from different angles, making artistic creation and design thinking return to the special conditions of the site, producing unique expressive force and appeal.

Video: Video is the most narrative way to record the life and communication of villagers. Video shooting has the nature of scene, which can record the spaces, behaviors, contents and sounds. *It is a good way to record in a limited time, and* pic.I-17 *also the most direct way of expression.* Qiu Jianmin recorded with the image of her interview with the villagers, topic revolves around "stove with mobile phone", the scenes were different families sat by the fireside chating, images recorded various domestic space, the types of stoves and for traditional and contemporary life and through the Qiang clothing wear highlights the characteristics of space and time, it has also become one of the visual clues in the video works. Pan Hong and Lin Zicheng used video to record the villagers picking and selling apples on a day, using apples as clues to explain the villagers' lives.

Place Making: In a strange village, perceived the uniqueness of the environment with body, created space with locally discovered materials and methods, and finally let body participate in the completion process of the work. Toby's work "*Sauna*" was a direct response to the cold environment of the village. He combined his childhood knowledge of the traditional European sauna space and created a warm place in the village environment. *He also cured his cold in the whole process and gained* pic.I-18 *a new connection with the site.* Jana, Xu Xiaoxue and Zhang Peiyan made use of an unused room in the village to collect the unused, discarded objects in the pic.I-19 *village and displayed them in combination with the spatial characteristics to form a contemporary and local museum.* Christian used chairs and a small room in pic.I-20 *the dining room to create a simple puppet theater and put on a puppet show*

with some simple objects.

Production: Physical production can intuitively present and experience the special objects found in villages. Gong Bowei asked a local carpenter to make a traditional wooden lock and recorded the details. *The physical wooden lock aroused people's*
pic.1-21 *interest in the traditional defense system, and they could experience the fun of opening the lock themselves.* Wang Haiou found the special use of the stools made by the villagers. By making new stools together with the villagers and exchanging the old ones for the new ones, the old stools became vivid physical exhibits, and participating in the making of new stools also experienced the wisdom of the countryside with her body.

Events: Organizing an activity can trigger a strong sense of participation of villagers and participants. Chen Guiling, Huang Hui and Cory organized a stone painting activity with the participation of villagers. The story, painting and stone were integrated, and the villagers and the creators were closely connected to finish a rich work together. The ribbon cutting of the Village Museum by Jana, Xu Xiaoxue and Zhang Peiyan was also an activity with a strong sense of ceremony and enhanced audience participation. After the ribbon cutting, the three authors led everyone to visit the museum and read poems, so that the information conveyed by the work could be displayed in a situational manner. In the end, all the visitors chose an object they were interested in, took it and walked around the village, and put it back to the original site, to restore the house to its original state. *The birth and*
pic.1-22 *disappearance of the whole museum was full of events.* In Shenzhen, on the opening day of the exhibition, combined with the lion dance performance, everyone brought their own containers to the nearby restaurant to buy food, followed the parade back to the exhibition hall, and opened the exhibition food party.

Exhibition: Under the particularity of UABB In 2019, the idea of "exhibition displacement" was born. The exhibition hall of UABB was set up in 1 : 1 scale in a village, and activities were held in the exhibition hall, which was recorded with video and finally displayed in the exhibition site of UABB. Considered to the convenience and minimized the impact on the site, an informal solution was chosen.
pic.1-23 *Trees, stones and ropes purchased in the market were used to form a public "background" for the "exhibition hall" on a small platform in the center of the village to held "killing pig", boiling sulfur, bonfire party, roasting goat, closing ceremony.* In Shenzhen, the "Original Design" has been greatly compressed and transformed in the two exhibition halls, and the rural wisdom discovered by the students and teachers of the two universities in a remote Qiang village during this workshop is vividly conveyed through video and physical display.

Wen Yinghua

考察东村：思考与质疑

I–III

A Visit to the Dongmenkou Village: Thoughts and Doubts

考察东门口村：思考与质疑（节选）
A Visit to the Dongmenkou Village: Thoughts and Doubts (Excerpt)

关于村落主义　在当今政策的塑造下，农村和城市的人口比例是3：7，村落数量持续减少。这意味着，包括自给自足的生活方式等所有迷人的村落生活，和村落有关的知识也将逐步消失。我们以了解村落生活为己任，寻求重新解读村落知识的方式，并重新运用到当代城市生活中。我们并非要以怀旧的观点或保守的态度保留村落现状，而是力图发掘村落生活中的"智慧"，以供当代生活借鉴和带来新的生机。随着数字科技的持续发展，村落和城市生活渐趋相似。正如亨利·列斐伏尔（Henri Lefebvre）所言，"一切都将城市化"。当下，城市和村落的食物、服装和电视节目已经或多或少难以区分。我们都上淘宝网购，都用微信交流。但我们相信，两种日常生活方式间的差异仍然巨大，所以我们作出思考。

关于消费　启程前往中国前，我们脑海浮现的是浪漫村落生活的图片和影片，想象人们在菜园里劳动、圈养动物、捡柴、居住在同一个社区里。尽管这些想法听起来有些过时，但真实情况并无偏差。实际上，我们发现村民在菜园种菜、在市场卖菜毫无浪漫色彩可言，这些都是艰苦的工作。

汶川的村民对种苹果感到很自豪，他们种的苹果在当地闻名遐迩，他们采摘苹果并人工运送到山下，因为汽车和卡车无法驶过如此陡峭的山坡。因此，他们将苹果装在篮子运出去，单次运送量可达50公斤。由于收割苹果相关的大多工作需要手工完成，因此需要很多人手，发放多份工资。如果偶尔苹果欠收，村民倒不至于立即"饿死"，但也没有余钱买其他必需品了。

村落的消费水平非常低，后消费主义或许会觉得很明智。如果像村民一样，一件衣服可以穿上很多年，大家为什么还要追随潮流，每次换季都购置新衣服呢？每周都会有一辆小卡车驶进东门口村，兜售实用厚实的手工背心和花长裤。我很欣慰地看到基础消费满足了村民的基本需求，而同样的基础消费在城市则被分割为众多领域。

关于寒冷　在村落考察项目的筹备会议上，曾被提醒东门口村天气寒冷，我们当时并没放在心上。到达后才发现，当地确实很冷！上午十点，太阳升起的那一刻还好，会带来一丝暖意。但是下午四点以后，太阳消失于山背，天气迅速转冷。我根据经验选了一间带光照的房子，以为会暖和一些，但发现里面比外面还冷！墙壁透着寒气。

几天后，情况好些，我们已经习惯了当地气候，把所有衣服都套在身上。我每天穿着五件衬衫，两条裤子。某天清晨，有学生从卡车上买到了厚衣服。这是一间"行走的时尚商店"，四处流转，兜售衣服。并且，村落的蔬菜、米饭和肉都是在"移动商店"或汽车后备厢出售的。

东门寨没有商店，但有一间很好的旅馆，供我们在内工作。从东门寨步行15分钟，可到达山腰的另一个村寨，那里有几间小店、一所小学、理发店和地方政府（龙溪县政府所在地）。东门口村所在的龙溪县都在进行旅游业开发。

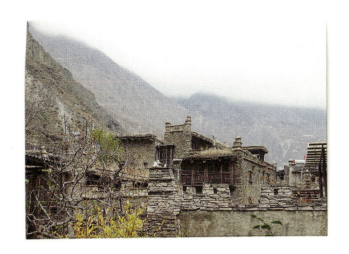

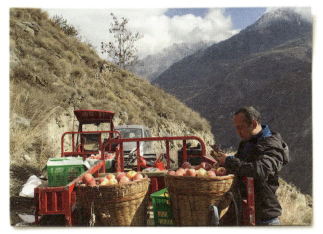

关于旅游 2008年的地震摧毁了当地许多房屋，政府决定重建村落，发展为旅游胜地。建筑原料是混凝土，但装修风格依然是旧式的，打造地方特色。混凝土表面粘岩石，安装木制窗户，保留地方风格。这样的村落真实吗？这引发了学生的广泛讨论。Jana、晓雪和沛彦用收集而来的材料举办的展览，展示了一种传统与当代物件之间有趣的后现代混合。

鉴于旅游业是当地的经济驱动力，这种做法可以理解。但对我们来说，想要研究到"真实的"村落就变得很困难。这个波将金（Potjomkin）式的村子是真正的村落吗？我也怀疑过这个村落是否仍有生命力？抑或只是一个博物馆？许多房屋看上去空无一人，只是安静等待旅游旺季的开始。除了旅馆员工，我感觉常驻村民并不多，实际上，我没见到多少人穿着传统的羌族服饰。我想知道，他们的传统装扮是为了我？为了游客？还是为了传统本身？

我仿佛置身于楚门的世界（Truman Show），一切都是虚假的。后来，我发现一间屋子里有猪圈，一开始从外面看以为里面什么都没有。那时我意识到，我们不应该太快地下判断。

关于空屋 部分房屋正被荒废，村落人口正在逐渐减少。通常来说，年轻人只要满16岁，便会前往城市，在村落也是如此。找工作迫使人们进入城市。在东门寨，由于父母在城市工作，经常由祖父母照顾孙子，每到周末，父母回来探望孩子，也给祖父母带回生活费。有时，祖父母随孩子迁往城市。

随着时间的流逝，村落的房屋渐渐被抛弃，成为一片荒芜。有些只用作仓库或作坊。住在附近城市的人如果要回村落，驱车20分钟即到。但是，促使人们离开的最大原因是恐惧。地震仅仅发生在11年前，这种恐惧恍如昨日。每天可以听到岩石从山上滚落的声音。部分是地区仍不稳定，部分是工人在爆破，防止大石块掉落。自地震以来，几乎每天都有大量的石头在摧毁道路，掩埋道路。去年八月，由于极端降雨天气，暴发大洪水，摧毁了山谷中的部分房屋。房屋连地基被冲走，整个躺在河床里。

关于后现代主义 在村落生活中，旧式生活行为和新技术设备形成了奇怪的后现代组合。在旅馆门口，有人杀猪前花了两天时间用柴火烧硫磺，然后喷洒于苹果树上。另外，村民种菜的数量看起来很少，应该只够养活自己家人。村落养殖猪、鸡激起了我的孩童记忆。

东门寨没有其他工业化的迹象，电动车除外。所有小摩托和三轮车都是电动的。手机无处不在，用它可以付款，可以翻译。旅馆老板的抖音账号拥有5万多个粉丝，他分享两岁双胞胎女儿的成长记录。

关于尊重 我们带着固有的城市思维而来，认为村庄的社会控制力非常强，村民之间没有秘密。正如我在《Dorf Machen（制造村落）》一书中所写，村民必须彼此了解，因为他们知道，有一天可能需要向邻居借糖或寻求更重要的帮助。因此，在街上相遇

时，互相都会打招呼。这一点对村民行为有重大影响。村落不存在匿名者。与其称其为"社会控制"，不如说是尊重！人们必须保持尊重，因为在任何情况下都不能简单退出。没有哪个地方可以像城市一样隐藏在匿名之中。

人们移居城市是为了摆脱社会控制，寻找志同道合者。这是城市居住的第一条规则，在城市可以与相同身份的人共同聚集，隐匿在不同场景中，相互尊重很简单，也很舒适。但在村落，即便邻居的生活方式完全不同，也必须尊重对方，这导致村民间的相互交往更加困难，但同时，也更吸引人关注，令人惊奇。

当然，我们被社交媒体和与无处不在的摄像头、定位和个人数据监控，这是城市另一种形式的控制和剥夺隐私。这些操作与尊重背道而驰。我认为这种控制形式基于恐惧：没人愿意在镜头前抢劫，也没人愿意在镜头前违法。这与商业利益和政治影响有关。这方面不是专指中国，而是世界各地普遍存在的现象，尤其是在全球新冠肺炎大流行时期。手机带来了社交控制，但毫无尊重可言！它使我们更加安全，阻止任何人靠近病毒。但手机、相机不尊重个人权益，我们放弃了匿名和自由。

关于双年展 我们可能永远无法理解展览背后的过程。抵达前几周，我们突然收到消息，称开幕推迟一周，原因不详。这时林茨团队的师生早已安排就绪，我们预订了航班、火车、酒店，变动计划牵扯太多方面了。无论如何，我们决定在深双展布展的同时，依然在原定日期举行预开幕。

我们旨在开展中国村落调研，并在深双展览分享调研成果。我们被要求必须在开幕式前的数周提交展览材料（村落考察前），由组委会审核。我们提交了部分中国学生连夜赶工的图纸，这样至少可以展出部分作品。为了进行数字化展示，我们增设了一些屏幕，并将影像资料也在开幕前几天交付。

但是在最后一周（即开幕前一周）走场时，才发现还有很多工作未完成。开幕前夜如奇迹一般，验证了一句著名的中国老话，"开场前夜必忙"。幸运的是，我们在深圳雕塑院获得了一个工作空间，在这里举行预开幕。广美和林茨团队的师生们共同布展，搭建观影区，放映学生研究课题的所有影片及拍摄过程。预开幕式上有两只中国舞狮和乐手表演，我们带了尽可能多的饺子，邀请人们共同参与。

关于智慧村落 在深港城市建筑双城双年展上，您可以观看我们所有的影片和幻灯片。在这里，我们展示了村落生活的研究，探讨村落生活是否智慧，并以某种方式进行梳理。有些技巧和行为充满智慧，值得妥善保护延续。您仍可以信赖村落的种菜和小规模食品生产，或许这比食品工业化远远智慧得多。当然，随着世界人口持续增长，我们需要生产大量食物，然而食品工业化不是值得信赖的选择。

这不等于人们必须挨饿。在20世纪60年代，欧洲的食品工业化程度就不如今天极端，当时人口甚至更多。当然，村落生活也不是百分百智慧的，如艰苦的体力劳动、寒冷天气等。但是，村民从来没有抱怨过这些问题，也许这些完全不是什么大问题。

因此，在我们的展览中，请不要寻找答案，而要探寻问题。毕竟，我们是一群来自城

市的学者，在有限的时间里前往寒冷的村落考察。无论我们的观察多么有趣，所得出的理解和知识也必然存在诸多不足。所以，当观察学生们的研究作品时，您可能会发现时而天真幼稚，时而粗糙不精，时而过于理想化。但是，这些作品包含许多奇妙又有趣的村落知识，打开了一扇探索"智慧东门寨"的窗口。

Ton Matton

On Ruralism: With the policy to have a population divided of 30% in the countryside and 70% in the urban areas, village life will decrease. This means that the knowledge of village-life will disappear as well, with all its fascinating aspects of local production. We tasked ourselves with learning about village life and asked if there was any way of interpreting knowledge from the villages and implementing it in our contemporary urban lifestyles. Not for any nostalgic reasons, and certainly not with a conservative attitude to keep the village as it is, but rather to find out if there are 'smart' aspects of village living which would be interesting to add to our contemporary way of living. With ongoing digitalization, it is clear that village life is becoming more and more aligned with urban life. As Henri Lefebvre wrote: everything will become urban. Already the cuisine, the styles and digital entertainment are more or less indistinguishable between urban areas and the countryside. We use the same Alibaba to shop, the same We-chat to communicate but still the differences in daily lifestyle are big, ⋯ so we think.

On Consumption: Before leaving for China, we equipped our imaginations with romantic pictures and films of rural life on the countryside; of people working in the garden, feeding their animals, gathering wood and living as a community which, albeit, looked a bit old-fashioned and, as turns out, it was. In reality, we discovered the villagers working in the garden to produce vegetables and sell them at the market which is hardly romantic; it is hard work.
The villagers proudly produce apples, for which their region is famous, picking the apples and carrying them down slopes too steep for cars or tractors. So, they carry the apples in baskets up to 50 kg at a time instead. PAN Hong and LIN Zisheng in the APPLE TEAM conducted a study of this routine. Most of the work is done by hand, so a lot of hands are needed which invariably produces a lot of mouths to feed. And although you wouldn't starve immediately if there was a bad harvest now and again, there would be no money to buy other essentials as well.

The consumption level in the village is very low, which, in a post-consumption ideology seems very smart. Why should one go about following fashion trends and buying new clothes every season if they can wear them for many years, as people in the village do? Every week a Pick-Up-Truck drives through the village, selling very pragmatic, thick quilted vests and trousers with floral motifs. It was comforting to see that this basic consumption level fulfilled the same basic needs for the villagers as in an urban landscape with many specializations.

On Cold: We took it a bit too easy when Xian told us in the preparation meeting that it would be cold in the village. As we discovered, it was! The moment the sun rose at 10 a.m. it became OK. You could get some warmth. But after 16 p.m., when the sun disappeared again behind the mountains, it became cold very quickly. Out of custom I'd enter a house where light was shining, offering a promise of warmth. But what a disappointment it was to find out inside was actually colder than outside! The walls radiated cold.

After a couple of days, it got better because we got used to it, and learned to wear all the clothes we had; five layers of shirts and doubling-up on trousers. Some students bought warm clothes from a truck on the occasional morning; a kind of mobile fashion shop driving around to sell clothes throughout the villages. Also, vegetables, rice and meat were sold in the village out of a mobile shop or car trunk. Our village Dongmenkou had no shop. Instead, it had a very good hostel which we could use for our work. The next village up to the mountain, 15 minutes by foot, had some small shops, a primary school, hairdresser and local government whereas Dong Men Kou was focused primarily on tourism.

On Tourism: After the earthquake of 2008, when a lot of houses in the region were destroyed, the government decide to rebuild the village as a tourist attraction. The old-style architecture was used to build atmosphere, in spite being made of concrete. But, with rocks and wooden windows glued over the concrete facade, the local style was preserved. It caused huge debates in the students whether this made the village authentic or not. The exhibition Jana, XiaoXue and Peiyan made of collected materials shows an interesting post-modern mix of traditional and contemporary objects.

Since tourism is the driver of the economy in this village, it is understandable. For us, doing research of the 'real' countryside was difficult. Is it still possible this Potjomkin village is the real countryside? I had my doubts as well if the village was alive or just a museum. A lot of houses looked empty, waiting for the tourist season to start. Except for the hotel workers, I had the impression that not many inhabitants remained yearround, and few I met actually wore traditional Qiang-style clothes. I wondered, are they doing this for me? For the tourists? For the sake of tradition?

I got the impression I was in a kind of Truman Show where everything turns out to be decoration. But then I saw a pig stable inside a house which looked empty from the outside, and realized our judgments were too quick.

On Deserted Houses: Some of the houses are being deserted, and the village population is gradually decreasing. The usual arguments are that the youth go to

the city as soon as they are over 16. It happens here as well. Finding a job compels people to the city. In Dong Men Kou village however, it happens quite often that the grandparents look after the grandchildren while the parents work in the city and on the weekend, they come visit their children. They bring in the money which is also used to take care of their parents. Sometimes it happens, though, that parents follow their children to live in the city.
So, houses in the villages are being left behind and deserted over time. Some are only used as storage or for workshops, while people move live in the nearby city, 20 minutes by car. But the greatest reason people move away from this village is that people are afraid. Since the earthquake happened only 11 years ago, people still remember the fear. Every day you can still hear rocks falling from the mountains. Partly because the area is still unstable, and partly because of controlled explosions by workers to prevent bigger rocks from falling down. Since the earthquake, there have been avalanches of stones almost every day destroying and burying the roads. Last august there was a huge flood because of extreme rainfall, destroying some houses in the valley. The washed-away houses remain intact as they slid from their foundations and lay in the riverbed.

On Post Modernism: The village life had a strange post-modern mix of very old-fashioned behavior and new technology. In front of our hostel, before the killing of the pig, some men spent two days cooking sulfur on a wood-fire which they used to spray the apple trees. Also, the vegetable production looked very small scale, only to feed themselves and the pigs and chicken like life as I remember from my childhood.
In Dong Men Kou village, there were no signs of industrialization, besides the transportation that was largely electrical. All scooters and three-wheel trucks drove on electric power, as did most of the cars. The mobile phone was everywhere. You could pay with it and use it as a Dolmetscher. The hotelier had a TikTok account with over 50.000 followers to show how his two-year-old twin-daughters grew up.

On Respect: We arrived with urban mindsets carrying the typical prejudice, that social control in a village is extremely strong and that everybody knows everything about everyone else. As I wrote in my book *Making Village*! Villagers have to know each other because they are aware that one day, they may need their neighbors to borrow sugar from or provide more serious help. So, you greet everyone when you encounter them in the street. This has a major influence on behavior. There is no anonymity in the village. But instead of calling it ' social control ' I would like to call it respect! You have to be respectful because there is no situation you can simply withdraw from; no place where you can hide in anonymity, like in the city.
People move to cities to emancipate themselves from social control and find people with mutual interests. This is the first rule of urban settlement. Here you can specialize and hide within your scene with people who have the same identity, which makes it easy to respect each other and provides comfort. But on the countryside, you have to respect your neighbors who live a completely different life than you do, which makes the contact much more difficult, but also much more fascinating and surprising.
Of course, we contend with other forms of control and invasion of privacy in the city

with the influx of cameras, location tracking and personal data collection through our social media activity. These operations have nothing to do with respect,I propose this form of control is about fear: nobody wants to rob me in front of a camera, and nobody acts against the law in front of a camera. It is also about commercial interest and political influence. I am not talking specifically about China here; we see it happen all over the world, especially now in times of the global Covid-19 pandemic. The mobile phone brings social control, but not respect! It makes us feel safer that nobody is allowed to be near us with the virus. But we forfeit some anonymity and freedom to the phones and cameras which aren't respectful of our personal interests. They operate on power, not on trust.

On the Biennale: One of the things we may never understand is the process behind the exhibit. Some weeks before we arrived, we suddenly received the message that the opening was delayed one week. The reason remained unclear. Because we already set up the program and organized and booked all flights, trains, hotel rooms, etc., it was too complicated to change our plans. We decided to do a pre-opening on the original date while they were building the exhibition anyway.

Our aim was to introduce our discoveries from the village and share our results in the exhibition. This became difficult because the material had to be delivered some weeks earlier, so the central political committee could check our work. We delivered some drawings the Chinese students made overnight so we could at least show some work. And we added some screens so we could make digital work. It was delivered a couple of days before the opening.

We had to follow some rules like don't draw Taiwan or Tibet on a map as independent countries. At first, we were not allowed on the building site, and when we did have a visit in the last week (one week before the opening) it turned out that a lot of work had to be done. On the magic night, the famous Chinese saying "the last evening for the opening promises to be a busy one" proved true. Fortunately, we got a working place in the sculpture academy. We used this place to do our pre-opening. We set up an exhibition, made a cinema where we showed all the films from the student projects and we filmed our process of getting there with our results. We were accompanied by two Chinese dancing lions, some music-players and we carried as many dumplings as we could carry, inviting people to join.

And on Smart Village: On the UABB location you can watch all our films and slideshows. There we exhibit our research of village life and whether it is smart or not. And in a way we managed this. There are some smart techniques and behaviors which are very good to keep and to maintain.The gardening and small-scale local production of food which you still can trust is probably much smarter than the industrialization of our food. Of course, we need, with the growing world population, to produce a lot of food. But it's not a way we can trust.

That doesn't mean that we have to starve, Europe had more inhabitants in the sixties when the food industrialization was not so extreme as it is today. And of course, there are moments where village life is not so smart, the very hard physical work, the cold ... But since the inhabitants never complained about this, maybe it is not such a big problem at all.

So, don't look for answers in our exhibition, but look for questions. After all we were a group of 20 urban students visiting a cold countryside for a limited time. However interesting our observations, our understanding and knowledge naturally come short. You may find students' work is sometimes a bit naïve, sometimes not precise or is idealistic, just as it should be. Nevertheless, there is much fascinating and interesting knowledge from the village in our collection of material showing the 'smart' village Dong man kou.

Ton Matton

灾后重建村落的日常生活

I–IV

Daily Life of Village Rebuilt after Disaster

灾后重建的村落日常生活（节选）
Daily Life of Village Rebuilt after Disaster (Excerpt)

本次调研的主题"智慧村落"，旨在发掘是否有一种存在于村落的日常生活和劳作中的智慧，一种有别于城市的科技和数字智慧，期许以此回应2019年深双展探讨的未来城市的数字化之路，并最终将调研的成果和迷思，与全球60多所高校、研究团体、设计单位的作品，一同呈现在深双展的福田站主展区。

就在新冠肺炎疫情被报道的一个月前，2019年11月底，来自奥地利（林茨艺术与设计大学space&design STRATEFIES）和中国（广州美术学院建筑与应用艺术学院）的约30名师生，跨越9个时区集结在广州。从那里我们坐了9个小时的高铁，然后又坐了3个小时的大巴，到达四川省汶川县。我们对东门口村和垮坡村进行了为期10天的实地调查。

从矿工到果农　东门口村所在的汶川县，隶属于中国四川省阿坝藏族羌族自治州境内，距成都149公里。汶川县境地势由北向东南倾斜，西部多分布海拔3000米以上的高山，最高处海拔为6250米。西侧通过横断山脉与青藏高原相连，317国道（川藏公路北线）途经此境。东门寨隶属汶川县龙溪乡联合村一组，是此次主要考察的居住地，海拔1500米，现有居民109户，约420人。另一考察地龙溪乡垮坡村，海拔2200米。

据考证，龙溪乡的最早羌族遗迹可追溯到1400年前，古时曾以茶马古道支线贸易和矿石开采为生。1995年采矿业被关闭后，当地开始种植经济果物。2008年震后重建，制定打造全乡旅游景区。节假日和当下，村民收入分为两大部分：节假日和旺季游客的居住接待，以及下半年樱桃、脆李、糖心苹果的果物售卖。当地逐渐缩小的城乡收入差距，让部分青年村民可返乡创业。

作为一场跨校、跨国、跨语言、跨习俗的大型考察项目，东门口村拥有接待团队住和餐饮的基础设施，又相对保留着自然农业景观和传统生活方式，加之我曾到访和熟知交通，遂在中国60多万个村落中选择了此行最佳考察地。

山寨的石房子？灾后重建策略　受限于当地木材稀缺，远古羌民就地取材，以独有的石质建筑，与汉族的木质建筑特征形成反差。羌族建筑，先在选好的地面挖一个深约1~2米的方形坑，以片石混合泥土堆叠墙体，厚实的墙体自下而上逐渐变薄，同时重心内倾，以向心力形成几堵墙的互相支撑。墙体同时是建筑的构筑结构和遮挡面。每栋羌寨的二或三层，以木质过街楼（吊脚楼式闭合连廊）从建筑内部户户相连。整座

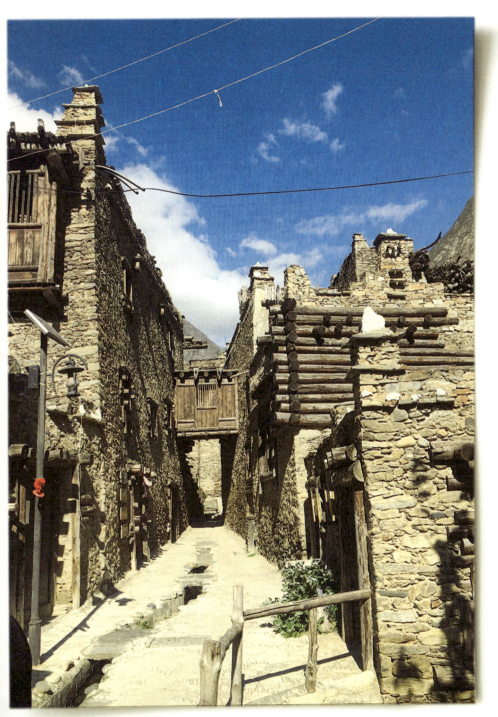

羌族村落从屋顶、空中连廊和路面户户相连，是古时的绝佳防御和公共交往体系，在地震时也起到了很好的横竖向减震作用。因此，整个东门寨有半数以上的百年石质建筑得以保留。

灾后重建的紧密周期内，在当地农民和"一省帮一县"的湛江援建队的公共协作下，部分塌损严重的古老羌屋被整体或局部移除，以现代砖砌框架结构迅速建成建筑主体。后因旅游景区的村落风貌改造，在新建筑外墙上粘贴片石，以维持整座羌寨的视觉统一性。这一建造理念和呈现效果，在我们这群外来者中形成截然相反的两种评价：一说这是山寨造假，以砖充石，滥竽充数，毫无美感，但显风俗化；另一说这是震后快速重建的必须选择，现代工艺和旧时审美结合，保持当地民俗装饰的视觉完整度。通过与村民的交谈，我了解到另一个版本：村民早已不再建造传统的羌族片岩建筑。除了这些独特建造技艺的流失，建筑所需的大面积石料开采早已不被允许。开河引水的大型水库建设也许是这场大地震的主因，加之长期的开山采石也造成了当地多发的泥石流，并且地震造成道路堵塞，长途负重调运大量石材来此建造，从时间、资金和人力各方面来说也不可行。对于生活在其间的村民而言，并没有"假"建筑的概念，部分村民以亲手参与的自家外墙风俗化打造为豪。感谢全村的风景区发展措施，他们不用再进城务工，可以留在家乡和家人一同经营家庭旅店和果林，住在自己宽敞的新房子里，获得一份虽然不高但可持续的收入。

传统村落图景和村民日常生活的可持续，是一场对专业人士善意提供的最佳方案，和当时当地的可行方案的平衡选择。村民长年累月积累的应对自然、寻找生机和自我执行的行事方式，似乎就是一种古老村落在走向现代化和城市化的日常生存智慧。

这也正如新型冠状病毒紧急封城和隔离在家的当下，为了阻断病毒的潜在接触传染途径，为了有限的医疗资源更好地服务已患病者，我们不得不重新建立和适应新的个人和城市的生活秩序。隔离期结束后的普通日常重启，正如灾后的重建，我们是否也会像村民一般做出最佳和可行之间的即兴平衡？

郑娴

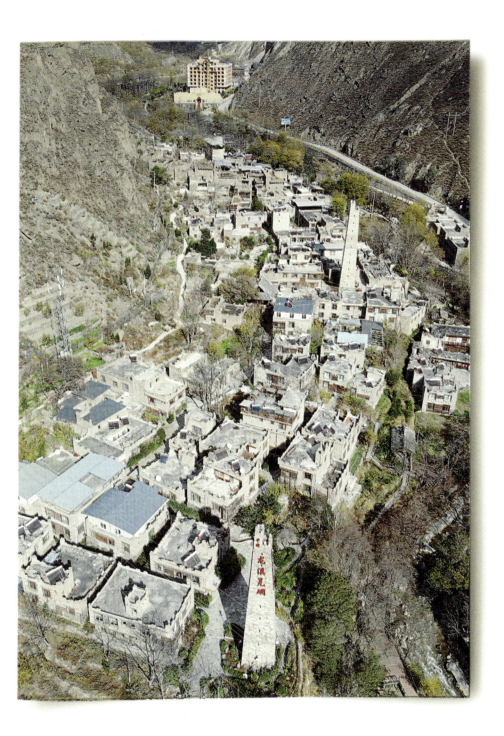

The theme of this research, "Smart Village", aims to discover whether there is a kind of wisdom that exists in the daily life and labor of the village, a kind of technology and digital wisdom that is different from the city, hoping to respond to the digital road of the future city explored in the 2019 Shenzhen Biennale, and finally present the results and myths of the research,together with the works of more than 60 universities, research groups and design units around the world, in the main exhibition area of Futian Station of UABB.

Just one month before this new coronavirus was reported, at the end of November 2019, about 30 teachers and students from Austria, (University of Art and Design in Linz;space&design STRATEFIES), and China, (Guangzhou Academy of Fine Arts;School of Architecture & Applied Arts), assembled across 9 time zones to gather in Guangzhou. From there we took a 9-hour high-speed train ride, followed by another 3-hours in the bus, to arrive in Wenchuan County, Sichuan Province. We conducted a 10-day field survey of Dongmenkou Village and Kuapo Village.

From Miners to Fruit Growers Wenchuan County, where Dongmenkou Village is located, is part of the territory of Aba Tibetan and Qiang Autonomous Prefecture in Sichuan Province, China, 149 kilometers from the provincial capital Chengdu. The topography of Wenchuan County slopes from north to southeast, and the western part is mostly distributed with high mountains above 3,000 meters above sea level, with the highest point at 6,250 meters above sea level. The western side is connected to the Tibetan Plateau through the Hengduan Mountains, and National Highway 317 (the northern route of the Sichuan-Tibet Highway) passes through this area. Dongmenzhai, which belongs to a group of Union Village in Longxi Township, Wenchuan County, is the main place of residence of this expedition, with an altitude of 1,500 meters and about 420 people in 109 households. Another study site, Cross Slope Village, Longxi Township, is 2200 meters above sea level.

According to the research, the earliest Qiang relics of Longxi Township can be traced back to 1,400 years ago, in ancient times had to tea horse ancient road branch trade and ore mining for a living.1995 mining industry was closed, the local began to plant economic fruit. 2008 post-earthquake reconstruction, the development of the creation of the whole township within the tourist attractions: holidays and the present, the villagers gold income two major parts: holidays and peak season tourist land residence reception, the second half of the cherry, crisp plum, sugar apple fruit sales. The local gradually narrowing income gap between urban and rural areas, so that some young villagers can return home to start their own businesses.

As a large-scale study tour project across schools, countries, languages, and customs, Dongmenkou Village has the infrastructure to receive groups for accommodation and meals, and relatively preserves the natural agricultural landscape and traditional lifestyle, plus I have visited and know the transportation well, so I chose the best place for this trip among more than 600,000 villages in China.

Fake Stone Houses and Post-Disaster Reconstruction Strategies Limited by the scarcity of local wood, the ancient Qiang people used local materials to form unique stone buildings, which contrast the wooden architecture of the Han nationality. In Qiang architecture a square pit with a depth of 1 to 2 meters is dug on the selected ground, and then they construct walls with pieces of stone mixed with soil, grass and steak rice. The thick walls gradually thin from bottom to top tilting inwards, leaning on each other for support. The walls act as both structural support and protective surfaces for the building. The second or third floors of each Qiang building are connected from the inside by wooden walkways (stilted platforms with closed corridors). The entire Qiang village is connected across rooftops, by air corridors and roads. The formation acted as an excellent defense and public communication system in ancient times, and also worked as good horizontal and vertical shock absorption during 28 \ 29 A Research to Smart Village in Dong Men Kou earthquakes. Therefore, more than half of the century-old stone buildings in Dong Men Kou Village have been preserved.

In the intense period of post-disaster reconstruction some of the collapsed ancient Qiang houses were removed in whole or in part, and the main structure was quickly rebuilt with a brick frame structure. It couldn't have happened without help from the public cooperation of local farmers and Zhanjiang aid construction teams, under "one province to help one county". Later, in spite of changes to the structure, the outer aesthetics of the buildings were meticulously recreated for tourists. Pieces of stone were pasted on the outer walls of the new buildings to maintain the visual unity of the entire Qiang village.

The dichotomous combination of modern structures and traditional façades formed two opposing opinions among our group of outsiders. Opinion one: "these new buildings, or perhaps the entire village, are fake; filled with bricks instead of stones, losing some ancient beauty and feeling overly kitsch". Opinion two: "these new buildings must have been designed with rapid reconstruction in mind after the earthquake, combining modern technology and old aesthetic to maintain the visual integrity of local folk decoration". Through conversations with the villagers, I learned another fact: the villagers no longer build traditional Qiang schist buildings. The villagers have long since abandoned the traditional Qiang schist structures. In addition to the loss of these unique construction techniques, the large areas of stone mining required for the construction have long been prohibited. The construction of a large reservoir to divert water from the river was the main cause of this earthquake, together with a long period of quarrying in the mountains, which also led to frequent landslides Meanwhile, the road blockage caused by the earthquake plus the long-distance transportation of stones to build there is hardly feasible in terms of time, capital and manpower. For the villagers living there, there is no concept of "fake" buildings, and some of them are proud of the modified designs of the external walls, which they personally participated in forming. Thanks to the village's tourism development, they no longer need to work in a city factory, but can stay in their hometown and run guesthouses and fruit groves with their families, and live in their spacious new houses, earning a modest but sustainable income.

To sustain the traditional village scenery, and the villagers' daily lives, is a balancing act between the best advice offered in good faith by professionals and the feasibility of the restorations. The villagers have accumulated many years of cooperation with nature, finding vitality and strength, developing many survival tactics, which endure during a time of modernization and urbanization. The life and fighting spirit taken away by the disaster are both terrible. The tragic picture of a body stuck under stone and shoes placed in a pot are like a hyper realistic grotesque painting. It destroyed the accustomed lifestyle and typical scene of the village.

Just like the sudden emergence of the new coronavirus, city closures and self isolation became necessary adaptions in order to better serve the sick who have limited access to medical resources. We must re-establish ourselves and adapt to a new urban life order. The return to ordinary life after the quarantine period will be like the reconstruction after the earthquake. Will we also make improvisational balance between the best and feasible adaptations as the villagers did?

Zheng Xian

羌
Qiang

I-V

羌
Qiang

东门寨有着两千多年的历史记忆,从汉朝时代的边关要塞,至后来作为古丝绸之路和唐朝时的茶马古道进出藏区的重要通道,古羌释比文化发源地和成都平原出土的文物都与之戚戚相关。在灾后重建时考虑到其文化元素,政府以政策的支持取消了其原始的耕作方式。

布局 东门寨地处在杂谷脑河畔,受三山二水形成的独特的气候条件影响,昼夜温差在12℃~18℃之间,常年平均降水量在350毫升左右,是典型的干旱河谷地带。过去,东门寨的经济以农耕和采"金刚砂"为主。采矿解决了当地百姓一时的基本生存问题,但对自然环境造成了不可估量的破坏。后来经农业专家勘查,本地无论是气候,还是海拔,都特别适合"车厘子"(甜樱桃)生长,果肉厚实,味道浓厚、甜美。在当地政府的扶持和带动下,老百姓广泛种植,成为当地的主要经济来源。

运作思路 用什么来改变百姓的生存空间?在2000年时,在国家政策的支持下,我们采取了以矿养树,在采矿的同时,积极广泛种植和培育果树,基本形成现代农业的雏形。随着国家政策的调整,对中小企业、矿场的关停,东门寨已形成了水果的试产阶段,为提升产值打下了基础。

地理位置 羌人谷位于汶川县灞州镇(原龙溪乡)。龙溪乡位于汶川县城以北,地处汶川、理县、茂县三县交界处,是羌族文化的核心地带,现辖8个行政村和16个村民小组,总人口4600人左右,而东门寨属于龙溪乡,全村共有农户260余户,1000余人,羌族人口占全村人口的98%,是典型的民族聚居村落。东门寨被誉为"西部羌人谷,释比发源地",除了有悠久的羌民族文化,龙溪作为丝绸之路和茶马古道进出藏区的重要通道,当年红军长征时亦在东门寨留下了可歌可泣的壮烈事迹。

释比故乡 羌人谷是我国羌族释比文化发祥地之一。释比,是羌族从事宗教活动的神职人员,在羌族社会中占有崇高的地位。释比主持仪式时都会击鼓诵经,羌族释比经典内容包罗万象,是羌族文化、生活的知识百科,但由于羌族没有自己的文字,这些内容以图像和口口相传的形式流传,因此释比经典也在逐步减少和消失。

2008年灾后重建东门寨,在国家的扶持下和当地政府的统筹布局下,东门寨把恢复建设与新农村相结合,重新规划新农村建设与特色农业生态旅游,打造出了一个别具特色的羌民俗文化展示区。灾后重建恢复了村落的原有风貌,更加体现出奇险为主、动静结合的特色。山寨泉水涌动,富有激情叠瀑、溪流小桥、景观水池、水景小品、水上栈道等,营造出水人相辉映、生生不息的景象。

唐成继

Dongmen Village has a history of more than 2,000 years. From a border fortress in the Han Dynasty to an important passage for the ancient Silk Road and the ancient Tea Horse Road in the Tang Dynasty, Dongmen Village is closely related to the birthplace of the ancient QiangShibi culture and cultural relics unearthed in the Chengdu Plain. Taking the cultural elements into account when rebuilding the village after disasters, primitive farming methods were replaced with the support of government policy.

Layout: Dongmen Village is located on the bank of Zagunao River. It is a typical arid valley with the unique climatic conditions formed by three mountains and two rivers. The temperature difference between day and night ranges from 12 degrees celsius

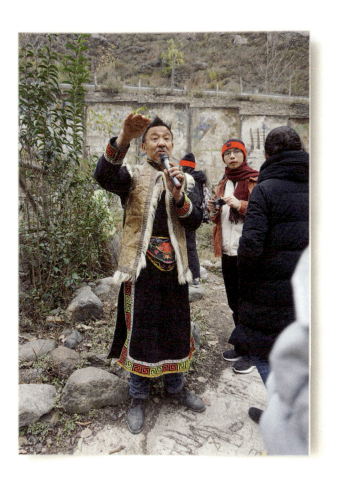

to 18 degrees celsius, and the average annual precipitation is about 350 ml. In the past, my village economy was based on farming and mining "emery". Mining solved the basic survival problem of local people for a while, but had caused immeasurable damage to the natural environment. Later, agricultural experts found that the local climate and altitude were particularly suitable for the growth of "cherries" (sweet cherries), with thick flesh and a strong, sweet taste. Under the support of the local government, cherries are widely planted, becoming the main source of local economy.

Operation Ideas: How to change people's living? In 2000, with the support of the national policy, we made use of the earings of mining to grow trees. While mining, we planted and cultivated fruit trees extensively, basically forming the seed of modern agriculture. With the national policy adjustment, the closure of small and medium-sized enterprises, mines, my village has formed a fruit trial production stage, to improve the output value of the foundation.

Geographical Location: Qiangrenguis located in Wenchuan County, Bazhou Town (the former Longxi Town). Longxi is located in junction of Wenchuan County, Maoxian County and Lixian County, which is the heart of Qiang culture.It is consist of 8 villages and 16 villagers groups, with the total population of about 4600 people. Dongmenkou Village belongs to Longxi Town, has a total of more than 260 families of more than 1000 people, and the Qiang people's population accounts for 98% in the total population, which is a typical minority village. Known as the "Western Qiang Valley and Birthplace of Shibi", Longxi is an important passage of the Silk Road and the ancient Tea Horse Road to Tibetan areas, as well as the historical passage with heroic stories of the Red Army During the Long March.

Hometown of Shibi: Qiangrengu is one of the cradles of Shibi culture of Qiang nationality in China. Shibi, the clergy engaged in religious activities of the Qiang people, occupied a high position in the Qiang society. When Shibi hosted the ceremony, they drummed and recited Shibi classics. The Shibi classics were the encyclopedic knowledge of the culture and life of the Qiang people. However, because the Qiang people do not have their own written language, these contents were spread in the form of images and speaking language, so the Shibi classics were gradually decreasing and disappearing.

In 2008, Dongmenkou Village was rebuilt after the Wenchuan earthquake disaster. With the support of the state and the local government, the village was renovated, reconstructed with new facilities,turning into an agricultural and touristic village, which created an unique proctection area of Qiang folk culture. This reconstruction restored the original village structure, and created more dynamic elements, such as spring, cascade, landscape pool, stream bridge, plank road on the water, to create lively image of the village life.

Tang Chengji

甲骨文羌

在我死后送上卷 就还给我羊的灵魂

先问问我行"羌"这个族群

我在玉床上给予甲骨文上我孔神

愿我"美羌美"益可义

我步戴美丽小稀在墨山三巅吟唱

你我挡戴融创羊皮抖落片片云羽

灵魂被历史的尽针带引

我找到羊

缝补我浮生与魂的情感

甲骨文空写无碧羌笛盆装秋雨

苍穹云峰琼岛雄鹰逆风之翔

"羌"兮羌兮若新生

而我已白发苍苍

发肤蹉跎我永无需再向祢借甲五百年

辛卯闰缘

II

存在的
图示

The Existed Totem

II-I

图形智慧
Graphic Wisdom

在这里
Being Here

# 图形智慧
Graphic Wisdom

我们收集了整个寨子的图腾，邀请孩子、羌民、游客一同创作，讲述图腾故事。然而，我们发现这些当地的民族符号，是新时代的新创作。当新的民族符号布满村落时，孩子们懵懂地知道羊是吉祥物，羌民们对于村落图形感到陌生，而游客却认为这是羌族古老的文化元素。那么，你如何认为？当传统的图像语言转译成民族符号时，是否是当代的图形智慧呢？

我们采集整个寨子的图腾纹样，羌族的图腾纹样主要是以动物、人物以及吉祥图案为主，整个寨子最常见的动物图腾主要有羊、牛、龙，人物主要有狩猎、战争、释比等图像，吉祥图像有太阳、月亮、羊角花等。我们询问唐叔，这些图腾的作用，他说"这是羌族的信仰"，由于羌族没有自身的文字，因此，羌族的传统文化均由羌族的"释比"以言传身教的方式加以传承和延续，那么，《释比图经》是记录羌族传统文化的重要承载媒介以及重要图形语言，图形就是羌族的语言智慧。

带着在寨子里拍摄的图腾，我们开展了图腾故事收集行动。走访羌民的住宅，邀请老羌民述说图腾的故事。因为图腾和羌族是息息相关的，所以让我们快速地融入和羌民们的交流之中，我们围坐在火炉边听他们讲述着一个个我们好奇的"神仙的故事"。我们也进行文献资料查阅并与他们分享我们对图腾的理解，最后邀请他们与我们一起在以石头为载体的媒介上进行创作，再现图形智慧。

杨叔："白石图腾"是来自上天，是上天所赐。古代羌人在迁徙途中遭到了强悍的"戈基人"的侵略，于是双方激战连连。因羌人敬拜天神，热爱和平，天神便暗赐白石为武器，将戈基人打败，从而安居乐业，繁衍生息。所以在羌寨建筑中，屋顶、房檐、窗沿等地都会放置白石，以寓吉祥。

唐叔："羊图腾"——羊头，代表羌族人民。最先羌族是游牧民族，以放羊为生，羊是羌族主要的经济来源，羌族人民平日里也有穿羊皮褂、用羊毛纺线的习惯。后因与戈基人战斗，被迫从西北迁往岷江上游，传说大战中羌族天神给了羌人神谕，神会帮助系羊毛绳的羌人，于是羌人遵照神意行动，打败了戈基人，获得了土地。

余阿姨：羊与阳同音，"羊"就是"阳"的变相，羌族崇"羊"，事实上就是变相地对太阳神的崇拜。在长期的祭祀实践中，人们不自觉地将"太羊"一名反传给天上的日神，顺理成章地把天上的日神称作了"太羊"。

王阿姨：龙溪乡名字是由地形得来的，村子两旁的大山就犹如两条巨龙在此盘旋，而村子犹如一颗宝珠，引来两条龙相互争夺，像是双龙戏珠一般。而又有一条溪穿过，为人民带来水源。故而取名龙溪乡。此地得到护佑，人民安居乐业。

陈桂玲、黄辉

We collected the totems of the entire village, and invited children, citizens and tourists to create and tell the totems' story together. However, we found that these local national symbols are new creations in the modern times. When the new

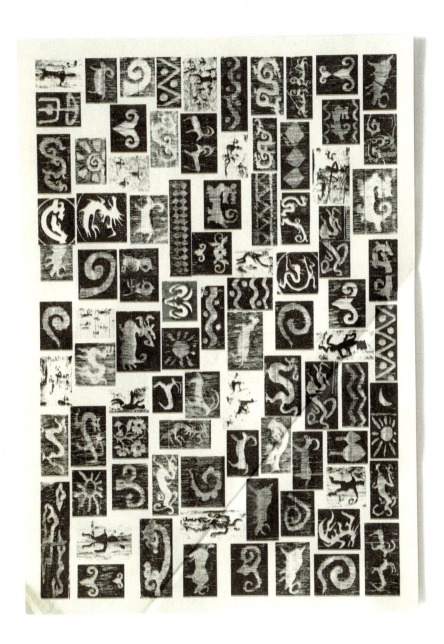

national symbols filled the village, the children probably only knew that the goats were mascots, Qiang people are unfamiliar with the village graphics, but tourists think it is an ancient cultural element of the Qiang village. So... what do you think? When the traditional image language is translated into national symbols, is this contemporary graphic wisdom?

Collected the totem patterns of the entire stockade, we discovered that the Qiang totem patterns are mainly based on animals, characters, and auspicious patterns. The most common animal totems in the entire stockade are mainly goats, cows, and dragons. We asked Uncle Tang the function of these totem patterns, he said that is the belief of Qiang, since Qiang do not have writing, the traditional culture of Qiang was inherited and sustained by Shibi of Qiang, therefore, *Shibi Tujing* is an important media of carrying traditional culture in the form of graphics, graphic is the wisdom of language of Qiang.

With the totem photographed in Dongmenzai, we launched the totem story collection operation. We visited the house of Qiang people and invite the old Qiang people to tell the story of the totem. Because the totem and the Qiang people are closely related, so we can quickly communicate with the Qiang people. We sit around the fire and listen to them telling us the curious "Fairy Stories" one by one. We also did some research in the literature to share our understanding with them, and finally invite them to join us to create patterns on stones as the carrier reproduces the graphic wisdom.

Uncle Yang: The "White Stone Totem" is from Heaven and is a gift from God. The ancient Qiang people were invaded by the powerful "Geji people" during their migration, so the two sides fought fiercely. Because the Qiang people worshiped the gods and loved peace, the gods secretly gave the white stones as a weapon to Qiang, so that they defeated the Gejis, thus living in peace and prosperity. Therefore, in the Qiang buildings, white stones will be placed on the roof, eaves, window edges, etc., in order to auspicious.

Uncle Tang: "Goats Totem" -Goat's head is to represent the Qiang people. The first Qiang people were nomadic people, and they lived on goats. Goats are the main economic source of the Qiang people. The Qiang people also have the habit of wearing goatskin gowns and spinning yarn on weekdays. After fighting with the Geji, they were forced to move from the northwest to the upper reaches of the Minjiang River. During the war, the Qiang gods gave the Qiang oracle which said would help the Qiang people tied woolen ropes, so the Qiang followed the oracle and defeated Geji, acquired lands.

Aunt Yu: Goat is synonymous with Yang. "Goat" is the disguised form of "Yang", which means sun in Chinese. The Qiang people adore "goat", which is actually the worship of the Sun God in disguised form. In the long-term sacrificial practice, people unconsciously passed the name "Tai Yang" back to the sun god in heaven, and logically called the sun god in heaven as "tai goat".

Aunt Wang: The name of Longxi Town is derived from the terrain. The mountains on both sides of the village are like two giant dragons hovering, and the village is like a gem, attracting two dragons to compete with each other, like a double dragon playing with a pearl. And there is a stream running through it, bringing water to the people.

Chen Guiling, Huang Hui

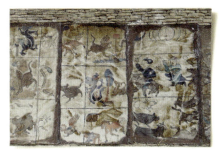

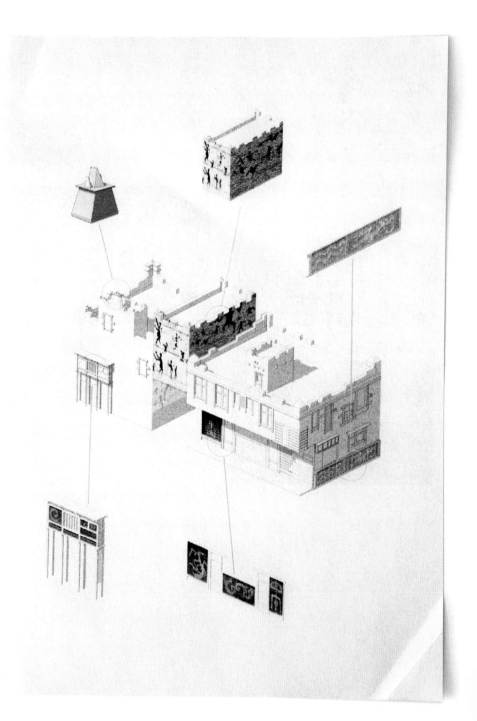

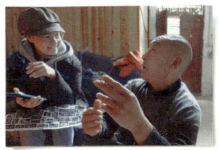
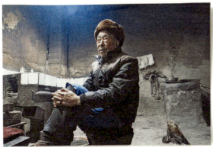
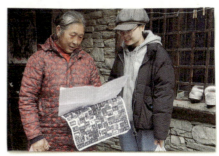
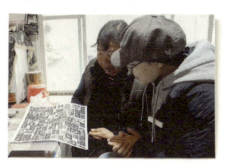

在这里
Being Here

本创作反映更多的是一种社会矛盾性，在当下快速的发展中城市被塑造得更加立体，但光照之下的暗处隐藏着被遗忘的"物"，从而引发一种新的社会问题探讨。被搭建至一半的"物"如同用水写在墙体上的字或口号一般，随时间的流逝渐渐被遗忘消失。而她通过拍摄记录为中介，讲述了一个被弃置后的废弃空间的呼喊——"Being Here"。

《寻找失落空间》中罗杰·特兰西将被废弃的场所，或是无组织、散漫的无功能空间称为"失落空间"，也就是当下被我们称为"消极空间"这一概念的场所。形成消极空间的原因有很多，例如前期的规划、设计过程的原因，场地持有者的问题以及政策或城市发展的变迁等。一处消极空间对城市而言可能微不足道，但持续恶化后容易造成城市的"信任危机"。

胡玥

The project reflects a social contradiction. In the rapid development of the city, the city has been shaped more three-dimensionally, but the forgotten "things" are hidden in the dark under the light, which triggers a new kind of Discussion of social issues. The "things" that are built to half are like words or slogans written on the wall with water, and they are gradually forgotten and disappear with the passage of time. And she used the shooting record as an intermediary to tell the shout of an abandoned space- "Being Here".

In *Finding Lost Space*, Roger Trance calls the "lost space" the abandoned place, or the unorganized and non-functional space, which is what we now call the "negative space". There are many reasons for the formation of negative space, such as the early planning, the design process, the problems of site holders, and changes in policies or urban development. A negative space may be insignificant to the city, but it continues. Deterioration is likely to cause a "trust crisis" in cities.

Hu Yue

系统与
非正规

Systematic and Informal

II-II

水³
Water³

非正规解决方案
Informal Solution

水³
Water³

作品《水³》的思路最开始源于对羌寨独特的村落空间形态的思索。在垮坡村调研中发现，由于受地形条件的限制，羌寨在高山峡谷中择地形相对平坦的地带为址，依山而建，因地制宜，充分发挥山区地形的环境优势，将不利的地形因素转化为独具特色的建筑形式。整个羌寨房屋错落，层层叠加，上通下达，宛如迷宫。水渠沿着道路设置，以明沟、暗沟相结合的形式附着于主要干道，或与道路并行，或在道路底下穿行。错综复杂的水管有的从墙体穿入村民的家中，有的又从家里穿出将水排入水沟，这一现象引发了我们对于羌寨水系统的兴趣。

在古代，村寨内有一种独特的排水设施叫主沟，通常与寨内的主路共同依山而建。寨内街巷集道路、水渠、过街楼、暗道于一体，空间组织复杂，虚实、明暗变化强烈，曲折婉转。村寨内部将山涧清水由引水渠引入寨内后，通过主沟转入地下，形成地下水网系统。四通八达的地下水系统满足了村民日常生活的取水用水。

现今，伴着用水需求的增加与地震破坏后基础设施的重建，每家每户都接入了自来水管，村民通过水管中的清水洗漱、饮用、灌溉田地，并将使用后的生活灰水排入主沟，经过自然过滤最终汇入山下的河流。水管的应用使原始的主沟功能被替换。

在羌寨中还有一种非常规意义上的水——黑水，它的使用方式从古沿用至今。黑水是天然的好肥料，其原材料为人们收集和加工后的人和动物的排泄物。黑水的原材料需要先在旱厕中进行发酵，为防止生虫，发酵时间不低于两个月。发酵之后的黑水便可以进行使用，一般村民一年为田地施肥两次。

在羌寨中水的不同使用与处理方式，与它的地理位置、村落形态等息息相关，清水、灰水、黑水三种不同的水构成了羌寨的水系统，从不同的层面影响着村民的生活，体现出与当代城市完全不同的乡村"智慧"。

地理位置、山地坡度、水源流向等因素形成了独一无二的垮坡村水系统，较少的工业化产品的使用、水流的湍急都为水的自身净化带来优势。因此，不需要将灰水和清水分离，灰水进入主沟会快速流走，完成净化过程，而黑水主要用于农家肥。

东门寨位于垮坡村的下游，地形较为平坦，因此取水方式较为复杂，需要节流山上的水源，建蓄水池，便于旱季的使用。而现代化的厕所设施使黑水经过化粪池处理后排入河流，仅有较少的几户人家还在使用黑水。因此，在交通位置更便捷的村落里，基础设施的建设更加完善，而对于当地的村民来说，这种水的处理方式是否"智慧"，是值得再思考的。

马旭龙、李薇

The idea of "Water³" originated from thinking about the unique spatial form of villages in Qiang Village. In the survey of Kuapo Village, it is found that due to the limitations of terrain conditions, Qiang Village chooses the relatively flat terrain in the mountains and valleys as the site, and builds according to the mountain, giving

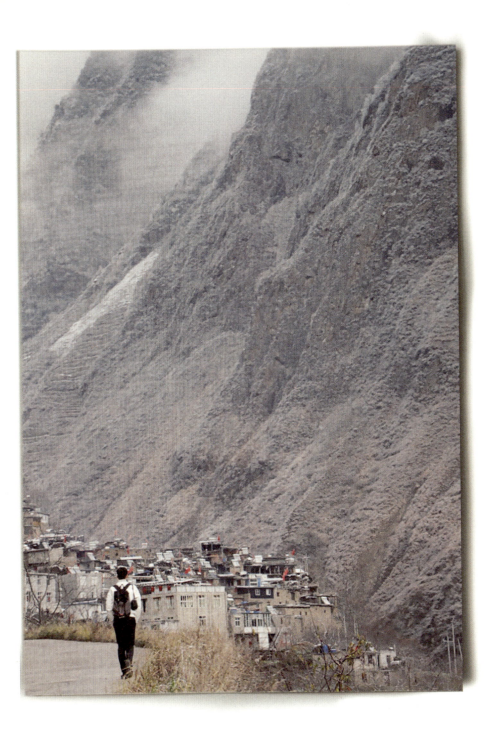

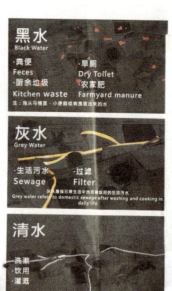
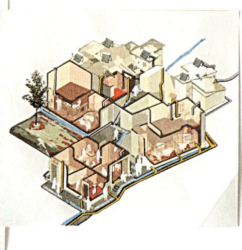
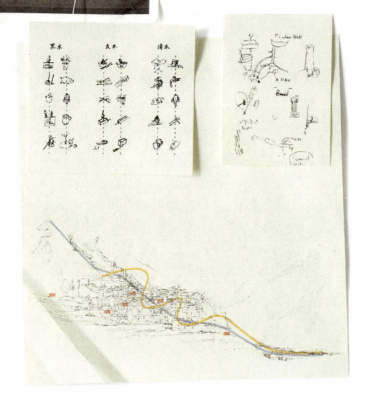

full play to the advantages of mountainous terrain environment, and transforming unfavorable terrain factors into unique architectural forms. The houses in the whole Qiang Village cattered, layer upon layer of superimposed, like a maze. Aqueducts are arranged along the roads, attached to the main road in the form of open ditches and hidden ditches, or running alongside or under the road. Our interest in the water system of the Qiang village was sparked by the intricate pipes that run through the walls into the villagers' homes and out into the ditches.

In ancient times, there was a unique drainage facility called the main ditch in the village, which was usually built along the mountain with the main road in the village. The streets and alleys in the village are a combination of roads, canals, street crossing buildings and secret passageways. The space organization is complex, and the virtual reality, light and shade change strongly. Inside the village, mountain stream water is introduced into the village by diversion channel and then transferred underground through the main ditch, forming the underground water network system. The underground water system in all directions satisfies the villagers' daily water intake.

Today, with increased demand for water and reconstruction of infrastructure after the earthquake, every house is connected to a water pipe, through which villagers washing, drinking and irrigating their fields, and discharging the used grey water into the main ditch, which will be filtered naturally and eventually into the river below. The original main ditch function was replaced by the use of water pipes.

There is also an unconventional water in the Qiang Village - black water, which has been used since ancient times. Black water is a fine natural fertilizer. Its raw material is human and animal's waste collected and processed by people. The raw materials of black water need to be fermented in dry toilet first, to prevent insects, fermentation time is no less than two months. The fermented black water can then be used, and villagers generally fertilize their fields twice a year.

The different use and treatment methods of water in the Qiang Village are closely related to its geographical location and village form. The water system of the Qiang Village consists of clean water, grey water and black water, which affects the villagers' life from different levels and reflect the rural "wisdom" completely different from modern cities.

Unique factors like geographical location, mountain slope, water flow shape the water system of Kuapo Village, the use of the less industrialized products, water rushing is advantage for the purification of water, therefore, without separating the grey water and water, grey water will run out quickly through the ditch, to complete purification process, and blackwater is mainly used for livestock.

Dongmen Village is located in the lower reaches of Kuapo Village with relatively flat terrain, so the way of water intake is relatively complex. It is necessary to reduce the water source on the mountain and build a reservoir to facilitate the use of dry season. Modern toilet facilities allow the black water to be treated in septic tanks and then discharged into the river, leaving only a few homes to use black water. Therefore, in villages with more convenient transportation locations, infrastructure construction is more perfect, and for local villagers, it is worth rethinking whether this water treatment method is "wise".

Ma Xulong, Li Wei

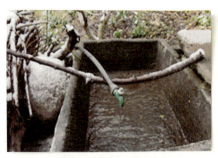

非正规解决方案
Informal Solution

在东门寨与垮坡村调研期间,我们走访了村子的不同角落,以寻找村中的生活智慧。在垮坡村,这个用树枝架起来的水龙头的使用方式引起了我的兴趣,我们认为这是村民对于有限条件的创造性的解决方案,是一种非正规的解决方案,是非常有价值的生活智慧。此外,在村里除了对物件的智慧改造以外,人对于空间的使用方式也是非常灵活自由的,同样透露出"非正规"的气息。因此,我开始收集村中的非正规解决方案。这一系列的物件、空间和行为是在羌寨里发现的非正式解决方案的一小部分,其中包含了物件加工的智慧、农业生产的智慧和空间利用的智慧,这为设计师提供了看问题的不同视角与灵感启发。

红色框内的是在东门寨和垮坡村发现的非正规解决方案,它们与许多城市中所出现的设计项目有异曲同工之妙,他们所面对和要解决的问题各不相同,但都以一种智慧的、非正规的方式达成了目标,并为生活带来了更多的美好。

黑色框内的是世界各地的设计师针对城市空间所做的设计,同样采用非正规、临时性、自下而上的策略来应对城市的变化、不均衡的发展、人的需求,充满了生活的智慧。

温颖华

During the investigation in Dongmen Village and Kuapo Villages, we visited different corners of the village to find the wisdom of life in the village. In Kuapo Village, the use of this faucet set up with branches aroused my interest. We think this is a creative solution in the limited conditions, which is an informal solution – a very valuable life wisdom. In addition to the intelligent transformation of objects, the way people use space is also very flexible, that also reveals an informal solution for space. Therefore, I started to collect informal solutions in the village. This series of objects, spaces, and behaviors is just a small part of the informal solutions found in Qiang village. It includes the wisdom of object processing, agricultural production and space utilization, which provides designers with different perspectives and inspirations.

In the red frames are the informal solutions found in Dongmenzhai and Kuapo Village. They are similar to many design projects in cities. They faced and solved different problems, but all achieved their goals in an intelligent and informal way, and bring more beauty to life.

In the black frames there are the design of urban space made by designers around the world. They also adopt informal, temporary and bottom-up strategies to cope with urban changes, unbalanced development and human needs, which is full of wisdom of life.

Wen Yinghua

农业的三个向度

The Three Dimension of Agriculture

II–III

龙舌兰
Agave

苹果的买卖
Apple

永续农业
Sustainable Agriculture

龙舌兰
Agave

羌人谷位于汶川县城西北方向约14公里,东门寨位于羌人谷的山脚,垮坡村位于山腰,这里的环境在2008年汶川大地震期间也遇到了山体滑坡和泥石流等自然灾害,村寨巧妙的选址和木构建筑避开了地震的影响,但是高耸的山体上依然布满了破碎的石块,日常也能听到碎石滚落的轰鸣声。

面对地震引发的自然困境,政府和当地的村民分别从三个层面进行维护和疏导。首先是人工对自然的控制,体现在强行人工避灾的策略中。东门寨东南侧的崖壁较为陡峭,几乎每天都有滚石落下,因此在崖壁下的公路上修建了涵洞,涵洞顶部已经堆满了土石,这种工程方式有效地保护了公路和地面。其次是人工对自然的管理,体现在对雨水管理和山体水网的经营中。山上农田区域挖渠引流,一方面流水可以进入农田,另一方面山体雨水可快速排入山下河流,避免引发泥石流等;同时山脚设置储水井,季节性储水用于浇菜牲畜用水等。第三是对自然的调适,体现在分布均匀且数量众多的成年龙舌兰,这些龙舌兰从山脚蔓延到山顶,有其特殊的用意。龙舌兰不是亚洲本土物种,引自南美洲,此处的龙山兰在一定程度上通过发达强韧的根系稳定山表土石,同时开阔常绿的叶片也能降低滚石的速度,减弱山体滑坡的危害。

羌人谷是汶川区域的一个缩影,这个区域在2008年至今十多年的修复中积累了面对震后余灾的经验,人与天调不仅是古人的智慧,在今天依旧是我们处理人与自然的方式。

何伟

The village is located about 14 km northwest of Wenchuan County. Dongmenzhai is located at the foot of the Qiang valley, while the Kuapo village is located on the mountainside. The environment was also hit by natural disasters such as landslides and mudslides during the 2008 Sichuan earthquake, and the village's ingenious siting and wooden construction avoided the effects of the earthquake, but the towering mountains were still strewn with broken rocks, the roar of falling rubble can be heard daily.

In the face of the natural difficulties caused by the earthquake, the government and local villagers from three levels of maintenance and dredging. The first is the artificial control of nature, reflected in the strategy of forced artificial disaster avoidance. The cliffs on the southeast side of Dongmenzhai are steep, with rolling stones falling almost every day. Therefore, a culvert was built on the road under the cliff, and the top of the culvert was already covered with soil and rocks. This engineering method effectively protected the road and the ground. Next is the artificial management to the nature, manifests in the rainwater management and the mountain body water net's management. On the one hand, flowing water can enter the farmland, on the other hand, the mountain rain water can be quickly discharged into the mountain river to avoid causing debris flow. At the same time, a water storage well is arranged at the foot of the mountain, and seasonal water

storage is used to water vegetables, livestock, etc. The third is the adjustment to nature, reflected in the well-distributed adult agave, these agave from the foot of the mountain spread to the top has its special meaning. Agave is not native to Asia. It's from South America. To a certain extent, the agave here stabilizes the soil and rocks on the mountain surface through its strong roots, while the open evergreen leaves can also reduce the speed of the rolling stones and the hazards of landslides.

The Qiang people valley is a microcosm of the Wenchuan County region, which has been recovering from the aftermath of the earthquake for more than a decade since 2008. The tuning of man and nature is not only the wisdom of the ancients, it is still the way we deal with man and nature today.

He Wei

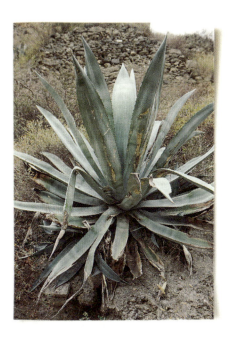

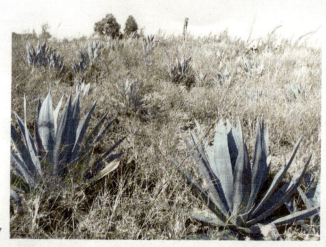

疑问 WHY

到羌人谷的第二天就看到漫山遍野的龙舌兰,直觉告诉我,这是有人刻意种上去的,为什么在山上会种这么多的龙舌兰呢?这个疑问在我脑海中挥之不去。

在冬季的西南高地,温度大约是 -1℃~10℃,耸立的山崖两壁除了偶尔看到的白色山羊,就是这种粉绿色像巨大花朵一样的龙舌兰,星星点点从山脚蔓延到云端,这种不断断重复的绿点极为打动我。

"它们是怎么出现的?它们为什么会在这里?"

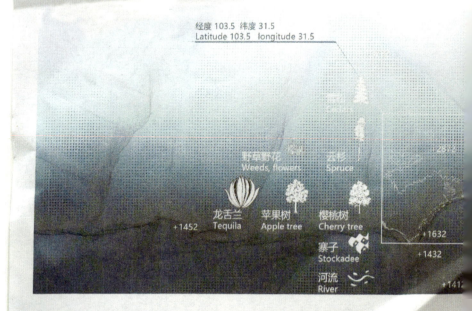

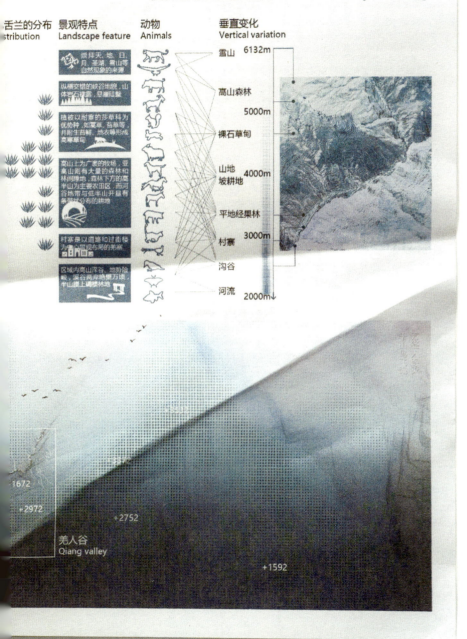

认识龙舌兰 WHAT

美洲龙舌兰（学名：Agaue americana）是天门冬科龙舌兰属的多年生常绿植物。多年生，草本，中、大型常绿植物。原产美洲热带。中国华南及西南各省区常引种栽培。

一生只开一次花，花后随种子的成熟，植株则逐渐枯死，龙舌兰一般也会经过很多年积攒养分，然后突然发芽"疯长"。生长十余年后老熟，大型植株于夏秋之间开花，花梗自叶丛中抽出，高可达5m以上，圆锥花絮，花淡黄绿色，通常在开花后花絮上形成许多株芽，株芽可用作繁殖。

纤维制品
- 草皮地毯
- 绳索
- 布匹
- 篮子
- 鞋

工业原料
- 油漆
- 塑料
- 化学燃料

食物
- 龙舌兰酒
- 糖

药用
- 生产甾体激素药物的重要原料

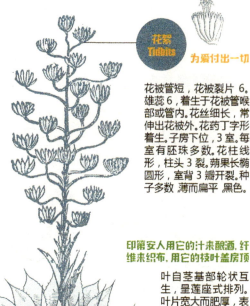

花絮 Tidbits — 为爱付出一切

花被管短，花被裂片6。雄蕊6，着生于花被管喉部或管内。花丝细长，常伸出花被外。花药丁字形着生。子房下位，3室。每室有胚珠多数。花柱线形，柱头3裂。蒴果长椭圆形，室背3瓣开裂。种子多数 薄而扁平 黑色。

印第安人用它的汁来酿酒，纤维来织布，用它的枝叶盖房顶

叶自茎基部轮状互生，呈莲座式排列。叶片宽大而肥厚，表面有蜡质，灰绿色，被白粉，长剑形，先端有硬尖刺。

肉质或稍带木质。叶缘常有刺或偶无刺，顶端常有硬尖刺。

茎极短

- 耐盐碱
- 防风固沙
- 涵养水源，保持水土
- 耐旱

LIFE CYCLE OF AGAVE

成长过程
Growth process

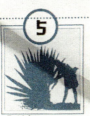

1 2周左右 / 2weeks
生根 / Strike root
播种：异花授粉，每年4-5月播种。
分株：基部幼苗取下栽种。
扦插：晒5-7天后等伤口愈合栽入土中。

2 2月 / 2moths
发芽 / Sprouting
种子的发芽最佳温度夜间为15℃以上，白天30℃左右，不能低于这个温度。

3 半年 / Half a year
生长 / Growing
冬季凉冷干燥对其生育最有利，越冬温度应保持在5℃以上，避免冻伤。生长旺季消耗的养分多。

4 5年 / 5years
成熟 / Maturation
大株发小苗一般是生长旺盛季节，即盛夏初秋。成长过程中容易发生叶斑病、炭疽病和灰霉病。偶有介壳虫的危害。

5 7-10年 / 7-10years
收割 / Harvesting
龙舌兰的球茎需要7～10年才能成熟。所以原材料价格更容易受到生长的影响。

龙舌兰的价值
How to Recycle Agrave Plant Parts
Value

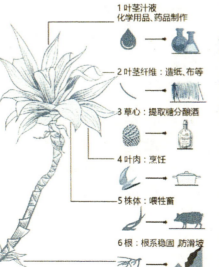

1 叶茎汁液：化学用品、药品制作
2 叶茎纤维：造纸、布等
3 草心：提取糖分酿酒
4 叶肉：烹饪
5 株体：喂牲畜
6 根：根系稳固 防滑坡

 园艺师 Horticulturist
材料科学 Material science
 厨师 Baker
 化学家 Chemist
商人 Trader
 服务员 Waiter
 司机 Driver
 设计师 Designer
工程工人 Engineering workers
农民 Farmer

龙舌兰的养殖
Value

龙舌兰喜欢光照充足，干燥，凉爽，15℃~25℃温度的生长环境。可以净化空气环境，很多人也喜欢在家里种植。

OUTDOOR 户外栽植
· 沙壤地
· 海滩
· 戈壁滩
· 墒墅
· 花园

INDOOR 室内栽植
· 卧室
· 客厅
· 书房
· 厨房
· 酒店

场所的历史记忆 WHEN

　　田埂上,砾石中,山坡上蔓延开的龙舌兰是什么时候开始出现的呢?关于这片土地发生过什么样的故事呢?羌人谷有一位老人,我们叫他达叔,他带着我们走过山谷,跨过溪流,一路讲述和羌族、古寨、地震有关的故事。

　　古代羌人分布极广,岷江上游是古羌人分布的重要地区。史前时期传说时代的大禹便出生于这一带,其后有文字以来的史籍均载这一地区为羌人所居,这些便是冉马龙为主的羌人。这部分羌人逐渐融合了从川、甘、青等地各个不同时代迁来川西北的邓至、岩昌、白马、白狗、党项等诸羌人,以及少部分已分化为其他民族后又迁入该地的吐蕃等少数民族和秦汉以来迁入的部分汉族,从而形成了现今的羌族。

　　路过断崖的时候山顶依然有滚石落下,轰隆隆的响,我们胆战心惊地走过去,回过头依然看到土石坠下。虽然地震过去10年了,汶川区域类似山体滑坡、崩塌等这样的震后次级地质灾害现象依然很常见,崖壁长出来的龙舌兰在一定程度上是为了抵挡和延缓滑坡带来的危险。

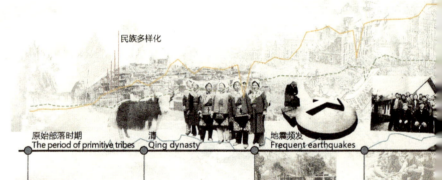

民族多样化

原始部落时期
The period of primitive tribes

清
Qing dynasty

地震频发
Frequent earthquakes

夏
About 2070-1600 BC

早在一万至八千年前就有人类在此居住繁衍,四千年至三千年前的新石器文化遗址已遍布全州各地,是川西蜀文化的重要发源地。羌人是最先出现在这片土地的人。羌族源于古羌,是中国西部的一个古老民族。

1636年-1912年
YEAR 1636-1912

1838年后,法、英帝国主义势力开始进入羌族地区,进行文化侵略活动。具有革命传统的羌族人民,对帝国主义的侵略,封建主义的统治和剥削、压迫,进行了长期英勇的革命斗争。1911年,茂县、汶川县的羌、汉人民举行反清起义,结束了清王朝在羌区的统治,支援了四川人民的反清斗争。

1933年
YEAR 1933

1933年8月25日15时50分30秒,地震导致叠溪古城全部建筑坍塌,并引发水灾,伤亡人数超过2万。

1989年
YEAR 1989

1989年9月22日时25分48秒,阿族羌族自治州小金内发生了6.6级强震,地震造成房倒断、地裂、山崩,地坏较大,次生灾害接经济损失严重。

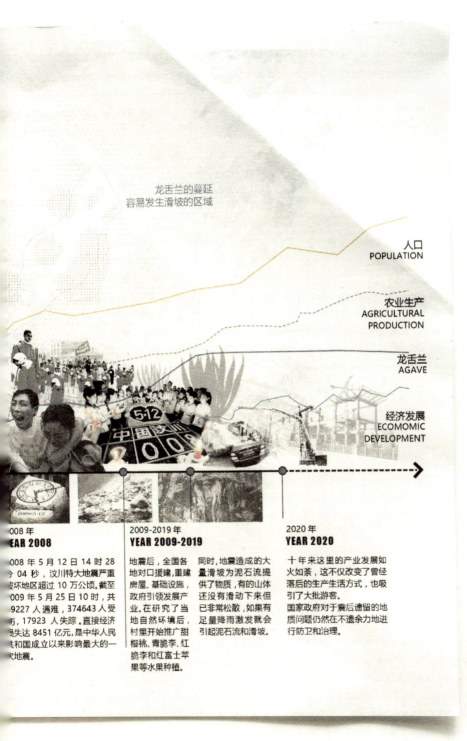

龙舌兰的蔓延
容易发生滑坡的区域

人口
POPULATION

农业生产
AGRICULTURAL PRODUCTION

龙舌兰
AGAVE

经济发展
ECOMOMIC DEVELOPMENT

2008 年
YEAR 2008

2008 年 5 月 12 日 14 时 28 分 04 秒，汶川特大地震严重破坏地区超过 10 万公顷。截至 2009 年 5 月 25 日 10 时，共 69227 人遇难，374643 人受伤，17923 人失踪。直接经济损失达 8451 亿元，是中华人民共和国成立以来影响最大的一次地震。

2009-2019 年
YEAR 2009-2019

地震后，全国各地对口援建，重建房屋、基础设施，政府引领发展产业。在研究了当地自然环境后，村里开始推广甜樱桃、青脆李、红脆李和红富士苹果等水果种植。

同时，地震造成的大量滑坡为泥石流提供了物质，有的山体还没有滑动下来但已非常松散，如果有足量降雨激发就会引起泥石流和滑坡。

2020 年
YEAR 2020

十年来这里的产业发展如火如荼，这不仅改变了曾经落后的生产生活方式，也吸引了大批游客。
国家政府对于震后遗留的地质问题仍然在不遗余力地进行防卫和治理。

如何应对震后次生灾害 HOW to Deal with the Secondary Disaster after the Earthquake

龙舌兰作为外来物种很好地适应了中国西南地区的自然条件,并且成为抵御震后次生地质灾害的有利武器。这种策略用很小的自然干预在一定程度上保障了安全需求,这是合理借助自然力量的一种策略。

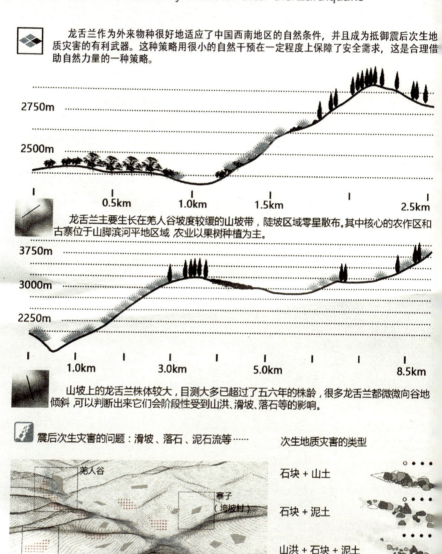

龙舌兰主要生长在羌人谷坡度较缓的山坡带,陡坡区域零星散布。其中核心的农作区和古寨位于山脚滨河平地区域,农业以果树种植为主。

山坡上的龙舌兰株体较大,目测大多已超过了五六年的株龄,很多龙舌兰都微微向谷地倾斜,可以判断出来它们会阶段性受到山洪、滑坡、落石等的影响。

震后次生灾害的问题:滑坡、落石、泥石流等……

次生地质灾害的类型

石块 + 山土

石块 + 泥土

山洪 + 石块 + 泥土

石块 + 植物

人工控制下的自然防御
通过强有力的工程介入减少地质灾害带来的影响

公路上的棚洞
The Value of Agave

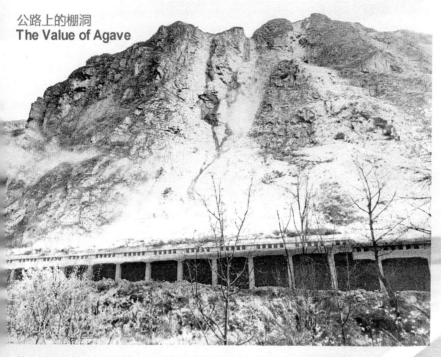

　　羌人谷的东侧山体极为陡峭，怪石玲珑，因此沿河谷东侧一带也是滑坡高频发生区域，沿着东侧开发的公路在震后逐年遭受山体断裂、滑坡等危害，时常更改交通路线。因而，仅仅依靠自然系统的防御显然不能完全抵挡这里的次生地质灾害。

　　面对频繁的山体落石，影响到人们活动范围的区域采取了更直接的人工介入，在山脚的公路上建起了抵挡落石的棚洞。

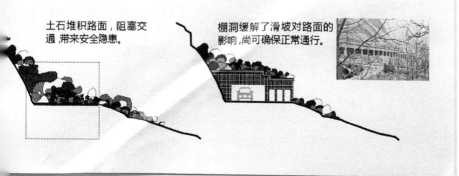

土石堆积路面，阻塞交通，带来安全隐患。

棚洞缓解了滑坡对路面的影响，尚可确保正常通行。

山地缓坡引水渠的作用
The Function of Diversion Canal on Gentle Slope in Mountainous Area

山坡上生长的龙舌兰有很多长在地梗水渠旁边，一层一层的水渠沿着山坡逐级出现。这些水渠的建造有效地管理了山上汇集的水流，缓解了山洪对山体强烈的冲刷，对于泥石流和季节性山体滑坡有一定的阻碍效果。同时在山脚有汇水井，为果林灌溉存储雨水。

◆ 人工管理下的自然系统——山地缓坡引水渠
Diversion Channel-Natural Systems under artificial management

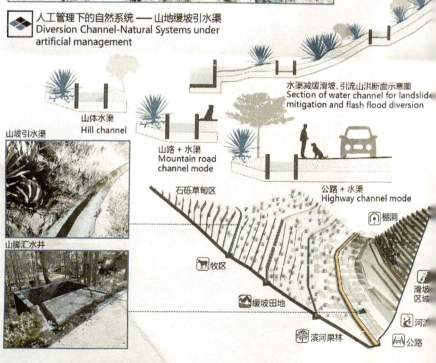

山坡引水渠

山脚汇水井

山体水渠
Hill channel

山路 + 水渠
Mountain road channel mode

公路 + 水渠
Highway channel mode

水渠减缓滑坡、引流山洪断面示意图
Section of water channel for landslide mitigation and flash flood diversion

石砾草甸区
牧区
缓坡田地
滨河果林
棚洞
滑坡区域
河流
公路

108

HOW 人工与自然的合力
HOW—The Combination of Human and Nature

地震后汶川山区依然面临一系列的次生地质灾害，当地政府与群众共同努力，以营造平安幸福的环境为目标，通过人工管控的介入试图干预灾难的发生或是减缓灾害带来的危机。由于阿坝州羌人谷位于地形险峻的山谷，汶川地震并没有造成太严重的古寨破坏和人员伤亡，但是造成了山体的震裂和表面破碎化，因此容易发生山体滑坡和泥石流等。面对以上可能或已经发生的灾害，具体的防御措施主要体现为三点。

- 借助自然的力量：通过龙舌兰的大面积种植和自我繁殖稳固山体、减少滑坡和滚石的发生概率。

- 人工管理下的自然：在山体层级建立水渠网络，纵向可以一定程度上阻拦滑坡和山洪，横向可以更快导流山洪，引入河谷无人区。同时山脚储水井定期蓄水。

- 人工控制下的自然防御：通过在坡度陡峭的山脚公路上建造棚洞抵御山体时常滚下的土石。

苹果的买卖
Apple

东门寨中羌民的交易都是通过一个移动式的售卖平台去实现的，每天九点左右，村头一个姓陈的村民会把肉菜装在小货车上，并用车上的音响大声地播放着音乐，穿梭于各个村落中，移动交易的路径把整个村落串联起来，而音乐也成为羌人谷一天生活的序曲。

以苹果为线索的追踪　临近东门寨的龙溪市场，地处国道一侧，呈带状分布。在水果收获的季节里，在这里都有批发交易。除了作为来往车辆的服务站和休憩区，这里亦是村民日常交往的场所。我们在此处观察场所的时间性和空间功能复合性等问题，研究它是如何体现乡村智慧的。

根据我们的调查了解，村口的市场并不是时常开放，仅用作羌人谷应季水果的售卖，主要是针对外地或过路客人所搭建的，较多时间则处于闲置状态。村寨里的日常交易更多的是通过售货小车进行，因此即使是在平时也少有村民在此交往。

市场里的很多食材则是要从汶川县城进货，因为羌人谷离汶川县城有20多分钟车程，如果是海拔更高的山上的村落，没有车的话，出行特别不方便。

调查方法　以售卖的"物"作为对象，跟踪拍摄"物"生产、运输、销售的过程，研究其中各种行为所折射出的人与人、人与物之间的关系，并探究隐藏其中的智慧。

通过寻访，我们找到了一位以种植水果为主要经济来源的羌人果农陈叔，取得他的同意，在一周时间里我们跟随其劳作并拍摄他的日常生活情况。经过一两天的拍摄及参与式观察，我们发现一系列有趣的问题，他们种植苹果的选址是精心挑选的呢，还是随机的？他们总会带着各式各样的容器上山采摘，为什么需要经过这么复杂的多道工序？

苹果的种植技艺　调查过程中路过果园，看到两户人家在劳作，他们在田里讨论着压枝的方法和技巧，怎样可以结出更大的果实，我们觉得这就是一种乡村智慧的重要体现。

陈叔坦言，他家的糖心苹果淘汰率十分高，在采摘过程中不小心碰掉的苹果哪怕没有损坏也都统统丢掉，而掉落的苹果一部分用于喂食猪和鸡，另一部分将以肥料的形式留在果林里成为肥料，参与了果林自身的循环。

随着气温降低，苹果树需要进行保温措施，熟石灰粉、硫磺、水按比例置入烧热的铁桶中不停搅拌，最后制作好的保温涂料装入喷桶，喷涂在树干上，用于保证果树安全过冬。果树平日的打理并不繁忙，修枝、挖草，时间不定，一年两次，修过树枝后的果树结果品质更好。

陈叔自己并不认为所有羌人谷的苹果都是好的，他觉得种植糖心苹果需要天时、地利、人和。冬天的时候忌下大雪，种植的场所要位于山的阳坡和雪线左右，早晚温差大，全天日照充足。

糖心苹果的挑选技巧　据村里唐叔讲，村里有几户人家以种植糖心苹果为主要收入来源，并且在唐叔眼中，羌人谷的糖心苹果品质上更优于新疆阿克苏苹果，我们尝了一下，也感觉确实如此。

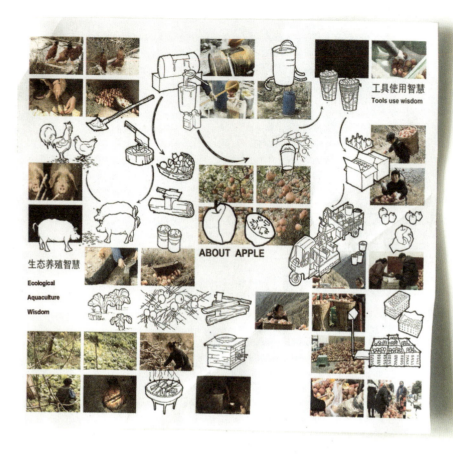

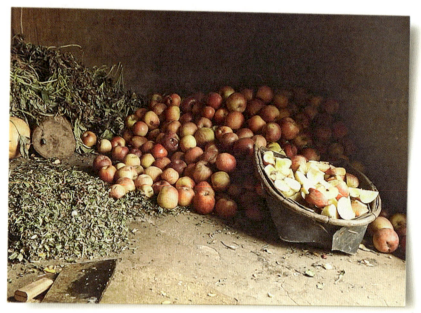

当下多数苹果种植的果农都会把苹果在开始结果后不久就套上袋子，这种套袋的方式有利于水果的生长，避免虫蛀、鸟啄，但苹果受到的光照也相对减少，导致苹果内部糖分的缩减，分辨这两种苹果的方式就是看苹果外貌，那种通红不带黄丝的苹果多数是套袋长大的，含糖量远不及接受日光强烈照射下长大的，而不套袋的苹果多表现为颜色红黄相错且有拉丝，因为不套袋而更容易遭受虫蛀与鸟类啄食，产量比一般标准化生产下的苹果更低。

家庭成员的协作　陈叔的苹果林位于半山腰平台上方一百多米处，因上下一趟果林极不方便，陈叔与妻子两人相互协作，将小一点的塑料桶挂在枝头方便苹果的采摘，装满后把塑料桶里的苹果移入竹筐里背下山，再统一用小货车运回家里。

晚饭过后，陈叔的母亲开始筛选苹果，对苹果进行分类、分级、淘汰，最后再进行打包存储。

销售的方式　陈叔售卖的方式有两种：一是顾客打电话下订单后，陈叔的两个儿子开车送货到家。二是通过网络平台售卖，陈叔把苹果运到快递处发货。虽然在县城打工的两个儿子在平日里依旧会在微信上帮陈叔卖水果，但售卖的效率和广度并不算高。

相比于苹果，现在网上以及市场中的"车厘子"更受大众的喜爱，收购价以及售卖价都远高于苹果，因此陈叔早已物色好一块适合的地方，也准备种植车厘子。对陈叔而言，他既是"物"的生产者，也是销售者，更是一名"网商"。什么"物"更适合当下的市场，就随着大流去做，也并不是坏事，但对"质"的把控依旧会是陈叔最看重的本质。在村子里调研的几天里，我们也帮陈叔在线上平台推销苹果，就是后来到了深港城市建筑双城双年展和学校的展场，我们也还在有意识地帮着推广他们这里美味的特产。

潘泓、林梓晟

Trading between the Qiang people in Dongmen Village is achieved through a mobile platform, at about nine o'clock every day, Chen, a villager lives at the entrance of the village, puts meats and vegetables on his van, plays music on the speakers loudly, then crossing around the villages. The route of moving trade connects villages, and the loud music becomes the overture of the day in Qiang Valley.

Tracking by the Clue of Apples　Longxi market, near Dongmen Village, is located on the side of the national road, showing a banded distribution. There are wholesale deals here during the fruit season. Apart from serving as a service station for vehicles and a rest area, it is also a place for villagers to interact with each other. We observed the temporality of the place and the complexity of spatial functions, to study how it embodies the wisdom of the countryside.

According to our investigation, the market at the entrance of the village is not always open, but only used for the seasonal fruit sales of Qiang Valley. It is mainly set up for the customers from other places or passing through, and most of the time is idle. Most of the daily transactions in the village are carried out by selling cars, so few villagers communicate there even in normal times.

A lot of food ingredients in the market are purchased from Wenchuan County, since Qiang Valley is more than 20 minutes away from Wenchuan County, if there is a village on a higher altitude, it is especially inconvenient to travel without a car.

Survey Method Taking "things" for sale as the objects, tracking and photographing the process of production, transportation and sales of "things", studying the relationship between people and things reflected by various behaviors, and exploring the hidden wisdom.

Through searching, we found an Qiang fruit grower Uncle Chen, whose main income is fruit planting, and obtained his consent. We followed him to work for a week and photographed his daily life. After a day or two of filming and participative observation, we found a series of interesting questions: Did they plant apples on a carefully chosen site or at random? They always carry all kinds of containers up the mountain, why do they need to go through so many complicated procedures?

The Art of Growing Apples During the investigation, we passed by an orchard and heard two families working in the field. They were discussing the methods and techniques of pressing branches to produce larger fruits. We thought this was an important embodiment of rural wisdom.

Uncle Chen admitted that the elimination rate of his sugar-hearted apples is very high. In the process of picking, the apples knocked off accidentally will be thrown away even if they are not damaged. Part of the these thrown apples will be used for feed pigs and chickens, and the rest part will be left in the form of fertilizer in the fruit forest as fertilizer, participating in the cycle of fruit forest itself.

As the temperature drops, apple trees need to carry out thermal insulation measures, pouring hydrated lime powder, sulfur, water in proportion into the heating around iron bucket and stirring, then coating the finished thermal insulation into the bucket, spraying on the tree trunk, used to ensure the safety of the fruit tree winter. Caring fruit trees is usually not a busy job, the time of pruning and weeding is variable but fixed in twice a year, after pruning the branches fruit trees will have better quality.

Chen himself does not think that all the apples in Qiang Valley are good. He thinks that planting sugar-hearted apples requires the right place at the right time. In winter, to avoid heavy snow, planting places should be located on the sunny slope of the mountain around the snow line, where temperature in the morning and evening differs largely, with adequate sunshine.

Tips for Picking Sugar-Hearted Apples According to Uncle Tang in the village, there are several families in the village growing sugar-hearted apples as the main source of income, and in the eyes of Uncle Tang, the quality of sugar-hearted apples in Qiang Valley is better than those from Aksu, Xinjiang, we agreed with him after tasting.

At present, most of the fruit growers planting apples will cover the apples with plastic bags when they start fruiting, which is benefits to growing of the fruits by avoiding eaten by moths and birds, but in this way sunshine was less absorbed by the apples, leads to the reduce in internal sugar.

A way to distinguish these two kinds of apples is by appearance, those grow-in-bag apples are totally red without any yellow ribbon, since they have lower internal sugar than those grew up in strong sunshine, which look scattered with red and yellow. Apples grow up without bags are more likely to be attacked by moths and birds, therefore the yield is lower than the apples grow up in standard production.

Collaboration among Family Members Uncle Chen's apple forest is located more than a hundred meters above the platform halfway up the mountain, because it is

extremely inconvenient to go up and down the forest, Uncle Chen and his wife work with each other, a small plastic buckets hanging on the branches to facilitate the picking of apples, after filling the plastic bucket they then moved the apples into a bamboo bucket to carry down the mountain, and then carried them back home with a minivan.

After dinner, Uncle Chen's mother began to sift apples, sorting, grading and weeding them out, and finally packing them for storage.

Way to sell There are two ways for Uncle Chen to sell: first, after the customer calls to order, Uncle Chen's two sons drive to delivery. Second, they sell through online platforms, and Uncle Chen delivers the apples to the express delivery office. Although his two sons were working in the county, they still help Uncle Chen sell fruit on we-chat on weekdays, but the efficiency and breadth of sales are not high.

Compared with apple, now cherry is more popular on the Internet and the market, the prices of purchasing and selling are far higher than apple, so Uncle Chen has been looking for a suitable place, ready to grow cherry. For Uncle Chen, he is not only a producer of "things", but also a seller. It is not a bad thing for him to follow the trend of popular "things" on current market, but the control of "quality" will still be the essence that Uncle Chen values most.

During the few days of research in the village, we also helped Uncle Chen to sell apples on the online platform, as we also bought some of them. Even when in the exhibition hall of UAAB later, we also consciously helped to promote this delicious specialty.

Pan Hong, Lin Zicheng

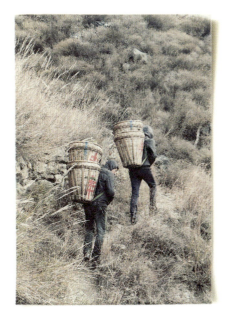

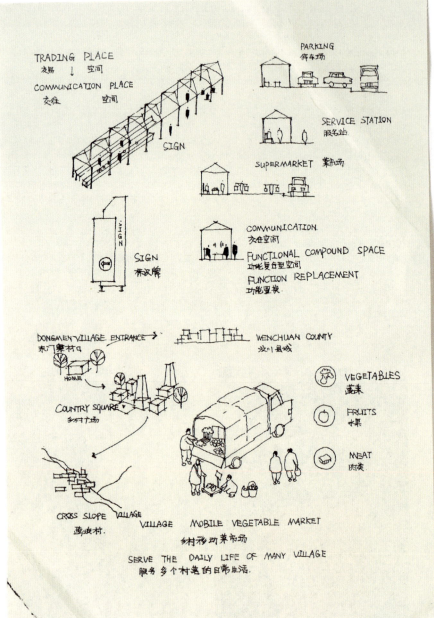

2000米海拔

地形 影响。

梨用索道. 梨子种了1800多棵

苹果用背.

施肥用背. 开春才施肥 (一个星期左右) 或请人 (一天120)
　　　　　　　　　　　　　　　　　　　7~8个. (两天).

羊尿, 100多只. 　半月加一次水.

七八吨羊尿.

地上搭房子.

存羊尿.

早上七点起.

八点去管理树枝.

才~6点才一下. 挖草, 修枝, (各有季节) 喷
　　　　　　(车两块)(一年一次).
　　　　　　　　修完
　　　　　　　　结果
　　　　　　　　更好.

　　　一年喷三次农药.

　　　还没结果的时候要喷一下.

原本修房子的时地步. 人多.

　400多人. 外出打工九十人.

永续农业
Sustainable Agriculture

永续农业的思想在羌寨中深深地扎下了根，让先前不了解它的人们，感叹大自然的力量，与羌民们的智慧。这本图文并茂的漫画，让我们看到羌民是如何建立可持续系统的，并利用自然规律让该系统能自行供应所需，不断循环利用自身的废弃物。这种不需要依赖城市供水管线或污水处理设施的系统，每年能为村民省下不少运作费用。

当我们从现代化列车上走下来，来到乡村，带着好奇的目光，敏锐地捕捉所有的一切。一些神奇的绿色基础"设施"非常具有吸引力，这些"设施"包含着方方面面，小到嫁接移植，大到排水灌溉，都在《永续农业》中以漫画书式的语汇表达着。

在城市中，先前的发展进步带来了快节奏的生活，快速、便利普及到家家户户，但作为人与自然的对话，却在这个过程中不断被切断。随之带来的城市问题使我们面临新难题，如何恢复对话，我们可能需要认真思考一下这些农耕智慧。

羌寨由于自身的地域特点和文化特色、农业作物的不同，会产生属于自己的耕种方法，比如针对樱桃树的培育等。除去地方特色，也有不少是适用于全国、全世界的绿色智慧。这些技术手段往往价格低廉、实施简单，也不失美观，它们是人与自然之间的对话。

The idea of sustainable agriculture has taken deep root in the Qiang Village, which makes people who do not know it lament the power of nature and the wisdom of the Qiang people. In this illustrated comic book, we see how Qiang has built a sustainable system that uses the laws of nature to feed itself and recycle its own waste. This system, which does not rely on city water lines or sewage treatment facilities, can save villagers a lot of operating costs each year.

When we get off the modern train, we come to the countryside, with curious eyes, keen to catch everything. The magic of green infrastructure—everything from grafting to drainage and irrigation—is fascinating, expressed in comic-book terms in *Sustainable Agriculture*.

In cities, the previous development and progress has brought fast pace of life, which has spread fast and convenient to every household. However, as a dialogue between man and nature, it is constantly cut off in this process. The resulting urban problems pose new challenges to how to restore dialogue, and we may need to think hard about these farming wisdom.

Due to its own regional characteristics and cultural characteristics, the Qiang Village will produce its own farming methods, such as cherry tree cultivation. Apart from local characteristics, there are also some green wisdom that can be applied to the whole country and the whole world. Often cheap, easy to implement and beautiful, these technologies are a dialogue between man and nature.

Christian Schrenk

传统的
角色

The Character of Tradition

II–IV

锁的智慧
Wooden Lock

桑拿
A Warm House

锁的智慧
Wooden Lock

羌族木锁作为羌族防御体系的重要组成部分之一，向当代人展示了羌族的智慧。独特的门锁工艺不仅体现了工匠对材料的精心制作，也体现了羌族人对环境空间的感知。本作品通过田野调查的方式，对汶川县东门寨羌人谷的木锁进行研究，探讨羌族木锁的制作工艺与开启方式，并以木锁为线索去了解羌族村落基于自然环境下的防御系统，展现出成型和根植于当地文化技艺的羌族木锁所具有的乡村智慧。

羌族村落大多依山傍水、据险而居，羌族人更是利用特有的建筑材料与自然环境防御外敌，以达到整体防御的目标。水渠、路网、房屋、过街楼和碉楼，构成了羌族村落地下、地上、空中立体交叉的防御系统。这种复杂而整体的防御系统能有效地保卫村落、防御外敌，体现了羌族人民团结互助，在资源有限的地理环境中，对空间环境进行巧妙利用的乡村智慧。

实地调查发现，东门寨羌人谷村共有木锁16把，其中只有两把木锁仍然可以正常使用。已知的木锁共有七种款式，其主要的构造特征相似，都是由"木奶奶"（木杻）通过不同的开锁位置进行开启与锁止，而门闩与钥匙的不同搭配方式则保证了木锁的独特性。

木锁由锁墩、门闩、"木奶奶"、钥匙四个主要构件组合而成，并安装在墙体内形成门锁洞。开锁过程中每个构件承担着不一样的角色，但相互之间环环相扣，缺一不可。开启木锁，需要将钥匙插入门闩，快速敲打"木奶奶"，与此同时顺势拉出门闩。整套动作需要快速连贯，在"木奶奶"因重力再次插入门闩之前将门闩拉出。木钥匙由于难以复制，且尺寸较大，不易携带，一般藏在锁洞内或门外某个角落，这种方法能解决当时一间房屋内居住人数较多的问题，同时也只有本族人或本家人才知道藏钥匙的位置，因此羌族人出门一般不携带钥匙。如同现代化的面部识别与指纹解锁一般，木锁为羌族人民设定了独特的生物识别系统。

龚博维

As one of the important components of Qiang's defense system, Qiang wooden locks show the wisdom of the Qiang to contemporary people. The unique lock craft not only reflects the craftsmen's meticulous production of materials, but also reflects the Qiang people's perception of the environment and space. This work by means of field research, selected the Qiang wooden locks in Dongmen Village, Wenchuan County as researching objects, investigated the making craft of Qiang wooden lock and opening method, and used wooden lock as a clue to understand defense system in Qiang Village which was based on the natural environment, showed the rural wisdom behind the molding and rooted local cultural craft of Qiang wooden locks.

Most of the Qiang villages live near mountains and rivers, and the Qiang people use their special building materials and natural environment to defend themselves against foreign enemies, so as to achieve the united defense goal. Canals, road

networks, houses, street crossings and watchtower form a three-dimensional defense system that intersects the ground, ground and air of qiang villages. This complex and integrated defense system can effectively defend villages from foreign enemies, which reflects the rural wisdom of the Qiang people's united and cooperating, and make clever use of the space environment in the geographical environment with limited resources.

By the field researching we found that there were 16 wooden locks in Qiang Village of Dongmen Village, of which only two were still in normal use. There are seven types of wooden locks. Their main structural characteristics are similar which were all opened and locked by munainai (wooden granny) through different unlocking positions, and the different matching methods of latch and key ensure the uniqueness of wooden locks.

Wooden lock is composed of four main components: lock pier, latch, munainai and key, and is installed in the wall to form a door lock hole. Each component assumes a different role in the process of unlocking, but it is interlinked with each other and indispensable. To open the wooden lock, you need to insert the key into the latch, tap the munainai quickly, and pull out the latch at the same time. The whole set of motion needs to be quick and consistent, pulling the latch out before munainai inserts into the latch again by gravity. Because the wooden key is difficult to copy and the size so large to carry, it is generally hidden in the lock hole or outside a corner, this method can solve the problem of a large number of people living in a house at a time, at the same time, only the local people or their families know the locations of the hidden keys, so the Qiang people generally do not carry the key outdoors. Like modern facial recognition and fingerprint unlocking, the wooden lock sets up a unique biometric system for the Qiang people.

Gong Bowei

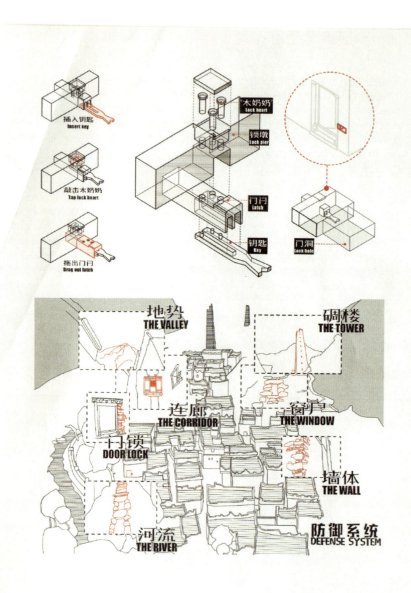

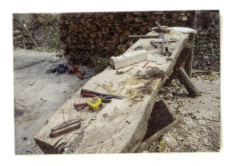
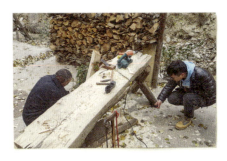
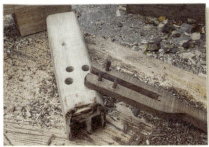

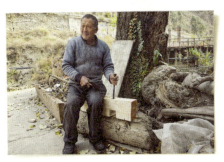
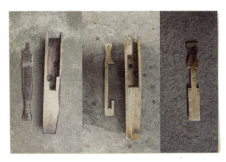

桑拿
A Warm House

最初来到中国村庄时,我立刻注意到了那些灯笼。这里的人们仍然遵循着古老的传统,例如他们认为死者的灵魂被储存在石头里,然后他们从四面八方收集白色石头,用来装饰他们房屋的屋顶。

但我根本不明白:在山村,天气非常寒冷。只有一个房间可以使我身体暖起来,但这是熏肉和保存熏肉的房间,那里满是烟熏味,没有一点新鲜空气,在客厅里仅有一个简易的电暖炉。我冻僵了,然后很快就生病了。我不停地流鼻涕,持续地咳嗽,喉咙肿胀到使我不能说话。

小时候,我总是扮演美洲土著印第安人。当我生病的时候,整个社区都会建造起一个帐篷。于是,我们从四面八方寻找石头,取来柴火并制作一个巨大的篝火。当这些石头从火中汲取热量变红的时候,我们把它们带到帐篷,在炙热的石头周围和生病的小伙伴们围坐成一个圈,治愈疾病。

When I first came to the village in China at the beginning of the Himalayas, I immediately noticed lanterns everywhere. I quickly realized that people still follow their age-old traditions. For example, they believe that the souls of the dead are stored in the stones. They collect white stones from everywhere and decorate their roofs with them.

But I didn't know at all: in this mountain village, there was only one room where I could warm myself, But that was the smokehouse, where meat is preserved. And it was so smoggy that I could not breathe at all. In the living room there was a heater, but a quite simple electric oven. Almost only an open heating spiral. I froze bitterly. I fell ill immediately. My nose was running, I had to cough constantly and my throat swelled so much that I had no voice left and was not able to speak.

As a child, I liked to play at being an indian. If I became ill as a Native American, my entire community would set up a tent. Then we would search for stones from everywhere, fetch firewood, and make a huge campfire. When the stones were hot and they werr glowing red from the heat, we would bring them into the tent, sit in a circle around the hot stones and heal with the warmth, in the community, me the sick friend.

Tobias Saatze

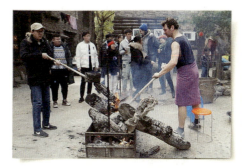 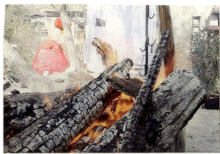
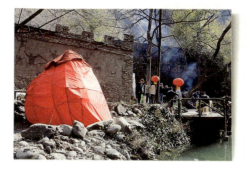

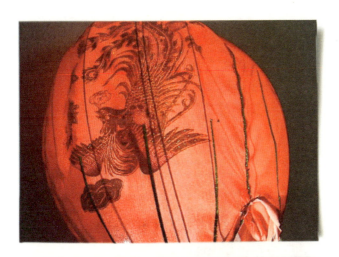

日常的美感

Daily Aesthetic

II-V

杀年猪
Slaughter for the New Year

自然的美感
Natural Beauty

杀年猪
Slaughter for the New Year

序曲 期待已久的杀年猪就要开始了,一个人走过来准备搭建案台,他拖拉着的铁质标语牌,在石板地上发出的声音,如同戏剧开场的锣鼓响起……

进行曲 虽然对于猪来说今天是个悲剧的日子,但是作为主角,出场还是威风凛凛,远远地就能感受到它的嘶吼与挣扎,它与旁边的人周旋的行进步伐,倒也交织出某种英武的节奏。

咏叹调 要想放倒一口三四百斤重的猪,不是一件易事,六七个成年男子用上绳索和浑身的力气,勉强能够控制住它。置身刀俎之境,猪还是要做最后的大声"告白",慨叹自己此生的感想。随后尖刀利落地刺入脖颈,鲜血汩汩涌出,主人家用黄色符纸蘸了它的血,同两支香一起点燃,为它祈祷送行。

谣唱曲 它在渐渐离去,两位师傅紧紧地扶着它,前后观望身体的抽搐,待看到血流尽了,便溺也排出来了,才算是放松下来。

重唱 亲朋们配合师傅将猪安置在案台上,旁边的炉火上煮着一大锅沸水,大家一边聊着家常,一边有条不紊地进行着后续褪毛和肢解的活计。

合唱 杀猪本就需要宽绰的空间,杀年猪作为一种节日仪式,更是得选在开阔敞亮的地方,这主人家屋前的坝子在村里应该是数一数二的,又临着水塘,周边似乎还专门做了石头景致的铺排,着实更像了演剧的舞台,一群人围拢在周遭,男人们轮番上阵做着需要体力的事,女人则指手画脚为接下来的精细活儿做着安排,老人们或独自观望,或抱着孙辈边看边传授内里的掌故。外来的游客因为气味、卫生和信仰等诸多缘故,大都远远地观望,看上去有些心不在焉,当然也有些人在为猪的往生而唏嘘低泣。

羌历年,每年农历十月初一举行。羌族民间认为羌历年是"过小年",春节是"过大年"。在此期间,羌人屠宰牲畜用于祭祀、庆祝及加工储备食物。

过去羌寨中的猪是养在每家每户的住宅中的,一般在首层或半地下空间里,与主人家的关系较为密切,现在因为发展旅游业,出于卫生和气味的考虑,很多都已迁出,另选地方养殖。

按照羌族人的习俗,杀猪时都会进行祭祀,感谢猪为族人提供了肉食,也祈祷它在死去的过程中能够少些痛苦。

杀年猪要求宰猪人不仅动作利索,还不能伤及猪的内脏,而且要尽可能地缩短猪的疼痛时间。杀猪一般都在开敞的院坝上进行,靠近水源和沟渠,以方便清洗。

在村民的记忆里,杀年猪是羌寨中最热闹和高兴的时刻,亲朋好友借机举行聚会,现在则多了旅游项目的表演含义。

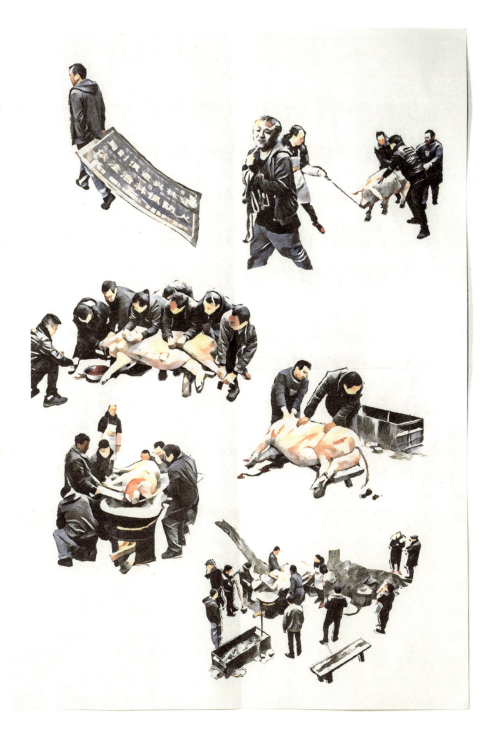

木匠吃酒醉 The carpenter is drunk hayeho 手上拿起锛锄睡 sleep wit
bricklayers are drunk, 泥巴做枕头 n
掌睡 sleep with a trowel in hand.
做枕头 anvil as pillow, 哈伊呀哈 haye
in hand. 石匠吃酒醉 The stonemaso
伊呀哈 hayeho 手上拿起錾子睡 sleep
bamboo craftsman is drunk
hayeho 手上拿起篾刀睡 sleep with a

五匠吃酒醉 Five Craftmen are all drunk, 五匠吃酒醉 Five Artists are
哈伊呀哈 HAYEHO! 手上拿起酒罐睡 Fall in

马做枕头wooden as pillow,哈伊呀哈
a chisel in hand.砌匠吃酒醉The
as pillow,哈伊呀哈hayeho手上拿起泥
吃酒醉The blacksmith is drunk,铮镫
手上拿起手锤睡sleep with a hammer
drunk,石头做枕头stone as pillow,哈
h a chisel in hand.篾匠吃酒醉The
做枕头bamboo as pillow,哈伊呀哈
e in hand.

nk,五匠吃酒醉Five Masters are all
drunk,酒罐做枕头tanks as pillows,
e with wine~

羌族民歌《五匠歌》羌族民歌原始古朴，音域不宽，一般在八度内，民歌多是二乐句、四乐句构成，旋律流畅，歌词方言种类多、土语杂陈，富于情感色彩。与《诗经》、汉乐府类似，这首民歌同样起源于劳动，也是对工匠劳动生活的艺术反映。人们从劳动中获取身体和心理上的满足，又不断进取、开拓生活新境界。

时下流行的羌族歌手云朵的演唱版本，传承和发扬了羌族民歌的传统，并融入雷鬼乐的节奏元素，表现出了劳作后纵情饮乐的豪情呐喊场面，还原了羌族人爽朗和野性的性格。

在工作坊开始之前，我从网上搜到了这首歌，被其中飘散出的自由激情深深打动，也想将这首歌作为此次活动中人人能唱的酒歌。可真到了杀年猪欢宴酒酣，才发现这首貌似简单的歌，其实不易唱好，一是简单的调式反而成了习惯于婉转抒情和复杂炫技的我们的难题，二是没有混杂艰辛与放松的劳作经历的人，也无从真正理解其中的情绪，更谈不上借此呈现抒发了。只好勉强作个略有共情的欣赏者吧，寄托对某种求而不得的生活状态的美好想象。

不过，这首《五匠歌》里没有屠夫的角色，也许在这里屠夫不算"匠"？

新年将至，四处都是杀年猪带来的气息。
腊肉不只是生活的必需品，更是商品和生活智慧的体现。
在广州美术学院里的展览引入村庄节日仪式的场景序列，以获得临场感。

杨一丁

Overture The expected activity of killing pig were going to start, the man coming was ready to building the table, dragging an iron label, making sound on the stone road, just like the gongs and drums before the opera.
March Although it was a tragic day for the pig, as the main character, the appearance is still majestic, from afar, you can feel its hissing and struggle, it was surrounded by people next to the marching pace, but also intertwined with a certain heroic rhythm.
Aria It's not an easy task to put down a pig in the weight of hundreds of kilograms, six or seven men with ropes and full power could only control it barely. Under the threatening of knife, the pig was still going to make a finally confession, sighed for the feeling of its life. The knife then stabbed into its neck sharply, with blood fountaining out, the host dipped its blood with yellow charm paper, and lit two incenses for its gone.
Cavatina It was passing away gradually. Two bachelors held it firmly, observing the twitch of body, until they saw the blood was drain and excrement and urine was discharged, they relaxed finally.
Septet The family and friends cooperated with the bachelors to place the pig on the table, a large pot of water was boiling on the fire next to it, and everyone chatted about family matters while the subsequent work of hair removal and

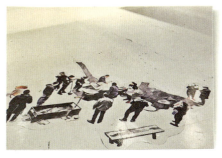

dismemberment was carried out in an orderly manner.

Chorus Killing pigs need large space, as a festival ceremony, killing pigs in the New Year has a higher requirement on wide place. The dam in front of the owner's house should be one of the best in the village, and it is near a pond, and the surrounding area seems to have been specially laid out with stone scenery, so it is really more like a stage for a play, with a group of people gathered around, the men taking turns to do the physical work, and the women giving instructions for the next The old people either watch alone, or hold their grandchildren while watching and teaching the inside story. Most of the visitors who came from afar because of the smell, hygiene and beliefs looked a little distracted, but of course some of them were sighing and crying over the death of the pig.

In the Qiang calendar, New Year's Day is held on the first day of October in the Lunar Calendar. From this day, Qiang people slaughtered livestock for sacrifice, celebration and food processing.

In the past, the pigs in the Qiang village were raised in every house, usually in the first floor or semi underground space, which has a close relationship with the owner's family. Now, because of the development of tourism, many of them have moved out to other places for breeding due to the consideration of hygiene and smell.

According to the Qiang people's custom, when killing pigs, they will offer sacrifices, thank the pigs for providing meat for the people, and pray that they will suffer less in the process of death.

Qiang Folk Song "Five Artisans Song" The folk songs of Qiang are primitive and simple, with a narrow musical range, usually within an octave. Most of them are composed in two and four musical phrases, with smooth melodies, lyrics and local dialects, full of emotional colors. Similar to The Book of Songs and The Yuefu of Han Dynasty, this folk songs was also originated from labor and is an artistic reflection of the working life of craftsmen. People obtain physical and psychological satisfaction from labor, and constantly forge ahead, open up a new realm of life.

The current popular Qiang singer Yunduo's singing version, inherited and carried forward the tradition of Qiang folk songs, and merged into reggae rhythm elements, showing the scene of drinking and shouting after labor, restored the Qiang people bright and wild character.

Before the workshop began, I found this song on the Internet and was deeply moved by the passion of freedom. I also wanted to use this song as a drinking song that everyone could sing in this activity. But I didn't realize that this song is difficult to sing until the dinking on the pig killing fest, on one hand the simple mode became a hard nut for us who was accustomed to tactfully sentiment and complex technique, on the other hand we don't really understand the mood in this song as we don't have the experience of mixing tired and relaxed after working, much less express the song. I have to be a grudging spectator of some kind of empathy, a beautiful vision of a certain undesired condition of life.

However, there is no role of butcher in this song of five Craftsmen. Maybe butcher is not a "craftsman" here?

Yang Yiding

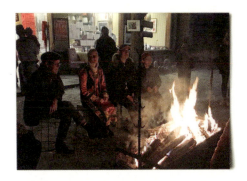

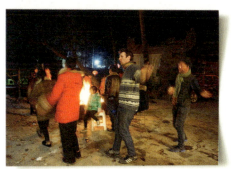

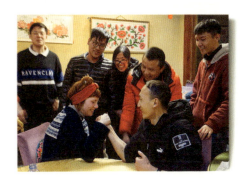

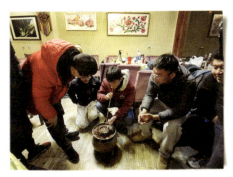

自然的美感
Natural Beauty

作为一个深双展的研究团队，我们决定用视频的方式推广一个想象中的博物馆。我们在村中找到一个闲置的房间，并用我们的艺术创作布置它。最终，我们创造了这个想象中的"当代羌族博物馆"，并称之为"人与自然的结合体"，我们尝试在这些创作中把在村落中发现的人造物品和自然物件、空间环境进行结合。我们制作了博物馆的推广视频，也组织了一场独家的展览开幕式，并用诗歌的方式表达了展览的艺术概念。

As a research group for UABB, Xiaoxue, Peiyan and I decided to participate in the exhibited video with a imaginary museum promo. We found a unsullied room, and filled it with our personally created art. Terminally, we found the imaginary "Museum of Modern Qiang". We called ourselves the "collective of human nature" and tried to combine things we found in the village with pieces from the natural surroundings. We put it on the food plates. (Busy) Susan filmed it and created a promo followed by an exclusive vernissage. I also wrote some poems and art concepts to embroider the exhibition place.

被转盘分割

它，不停地转啊转，
砍啊砍，
为了温暖和光明，
日夜不停，
直到最后，一切都被切碎~

自然·美

所有的，都活在他们，自己的美好里，
皮肤清白无暇，
身体健康结实，
没有丝毫的粉饰，
多么的美妙~

自然力量

拔地而起，
积极向上，
无惧伤痛，
眼盛星河，
心向远方，
若无其事，
野蛮生长，
无问西东。

Jana Simburger, 续晓雪, 张沛彦

Asundered by Busy Susan

Round and round it goes.
Cut by cut,
For warmth and delights.
For the day and the night
It never stops until the last one is chopped.

Natural Beauty

Everything stays in it's own beauty.
Unblemished skin.
The bones are safe and sound.
Without a mask or a colored cover up.
How marvellous.

Natural Power

Rising up from ground,
Go up positively,
Not afraid of pain,
Eyes full of stars,
Heart toward the distance,
As if nothing had happened,
Barbaric growth,
Be an avant-garde,
Explore every path,
Ignore old farts,
Follow your heart.

Jana Simburger, Xu Xiaoxue, Zhang Peiyan

废物的
价值

The Value of Waste

II-VI

凳子的智慧
Stools Story

智果
The Fruit of Knowledge

凳子的智慧
Stools Story

我们日常生活中离不开椅子和凳子，在村落中，凳子充当了"媒介"的角色，为村民提供了更为便利的交流的机会。凳子也体现了村民的小智慧。一方面，村民以自己的方式重新设计凳子并解决真实的生活问题（野生设计）；另一方面，凳子也体现了他们对待身边物件的态度和感情。

我擅自对这些特殊的凳子做了个称呼："凳子+"。这些凳子本身算不上有什么特别之处，日常生活中几乎没有人会去关注这些凳子，但我们的日常生活中又离不开凳子的存在，正因为如此，凳子才显得特别地重要。而这些凳子的高度都为300~400mm，太高显得过于正式，这个高度刚好适于不同场合和不同人群使用的同时，还能更好地拉近人与人之间的关系。

在走访的过程中，我发现了两户居民——杨叔叔家和唐爷爷家比较有代表性，但这两户也呈现了两极的状态。

杨叔叔的家更显现代化，他们的旧房子在2008年汶川大地震的时候被震塌了一部分，于是直接在原址上重建了新房子，但同时也保留了一小部分旧房子完好的墙体。杨叔叔的家里有一套现代风格的沙发和许多凳子，而他们则更喜欢坐着凳子烤火取暖、聊聊家常。他们的凳子是利用旧房子的木头做成的，凳子的上面固定了从旧沙发里掏出的海绵。

唐爷爷是村子里的老人，儿女都在大城市里工作生活，而他和老伴则仍旧留在村子里生活，因为他说住不习惯大城市里的房子。他们的房子在村子里算是比较老旧的，地是水泥地铺上去的，屋子里的木头、墙壁也都被熏得发黑。平时他们除了吃饭会坐在椅子上，其余时间都是和老伴坐在凳子上烤火取暖，或与邻居聊天。他们凳子上的坐垫是利用废弃的旧衣服制成的。

进一步调研发现，凳子关系到村民们的社交关系，可以说是一种古老的社交工具。而且，凳子是利用他们身边的物品制作而成的，凳子本身也是情感的体现。所以，在后续的调查中，我以凳子为切入点分析了村民平时的社交方式，探讨了他们围绕凳子所产生的社交空间和人际交往关系。

项目进展到后期，我尝试与村民进行凳子交换，我与他们所交换的凳子也是通过"凳子+"进行制作的。我认为交换也是一种智慧，我的关注点并不在于物品本身的价值，而是在交换过程中所获得的高于物品价值的东西。在进行物品交换的过程中，无形之间促进人与人之间的信任关系的建立。

王海鸥

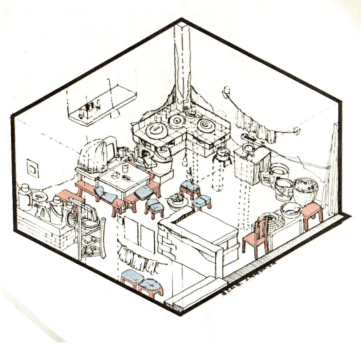

Chairs and stools are indispensable in our daily life. In the village, stools act as a "medium" and provide more convenient opportunities for villagers to communicate. The stool also embodies the wisdom of the villagers, such as the villagers redesign the stools in their own way and solved problems in reality (so called wild design). On the other hand, the stool also reflects their attitude and feelings towards the objects around them.

In Dongmen Village, every family has at least one small stools with a height of 300~400mm. No matter new or old, villagers fix a soft cushion on the bench. The material of the cushion is recycled from waste materials, such as motorcycle cushion, sofa sponge and so on. Therefore, I came up with the idea of understanding the villagers' daily life through the "stool", such as the role of the stool and why the villagers need such a stool. With such a question, I carried out research and found the wisdom of the village "stool".

In the process of visiting, I found two households—Uncle Yang's and Grandpa Tang's were more representative, but these two households also present a bipolar state.

Yang's home is more modern. Part of his old house collapsed in the 2008 Wenchuan earthquake, so they rebuilt it directly on the site, but some of the walls of the old house were still intact. Uncle Yang's home has a modern sofa and lots of stools, which they prefer to sit on to warm themselves by the fire and talk about their daily lives. Their stools are made of wood from an old house, fixed with sponges from an old sofa.

Grandpa Tang is an old man in the village. His children live and work in the big city, but he and his wife still live in the village, because he said he was not used to living in urban house. Their house was one of the oldest in the village, with a concrete floor and blackened wood and walls. Usually they will sit on a chair in addition to eating, the rest of the time is sitting on a stool with his wife to warm themselves by the fire, or chatting with neighbors. The cushions on their stools are made from discarded clothes.

Further investigation revealed that the stool is related to the social relations of villagers, which can be said to be an ancient social tool. Moreover, the stools were made from the objects around them, and the stool itself is also an expression of emotion. Therefore, in the follow-up investigation, I took the stools as the breakthrough point to analyze the villagers' social ways at ordinary times, and discussed the social space and interpersonal relationship generated around the stool.

In the later stage of the project, I tried to exchange stools with villagers, and the stools I exchanged with them were also made by "stool +". I think exchange is also a kind of wisdom. My focus is not on the value of the item itself, but what I can get in the process of exchange which is higher than the value of the item. In the process of the exchange of objects, intangible relationship promotes the establishment of trust between people.

Wang Haiou

椅子与使用关系尺度图

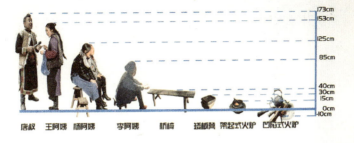

坐在椅子上交流的居民　　　　"椅子"+"故事"1

我原本是一件衣服，因为破的洞太多了，奶奶便把我变成了坐垫，重新利用我去守护她。

坐在椅子上交流的居民　　　　"椅子"+"故事"2

因为汶川地震，导致我与好几百年的房子分离了，我是旧屋的梁取下来的。

普通椅子VS椅子+

普通椅子　　　　椅子+

不同点	较为大件，不便搬运 椅面上一般为原材料 出现场地为院子或街边	小巧轻便，挪动便利 椅面上常有软质材料 出现场地为客厅
相同点	均为废弃材料制造，承载了村民对废弃物件的情感。高度均在300-400mm左右，这个高度能适应不同场合和不同人群使用的同时，还能拉近人与人之间的距离	
用途	日常交流，拉家常，拉近邻里关系。做日常的农活，例如刺羌绣、拾菜、烧柴煮饭等。围坐取暖烤火	

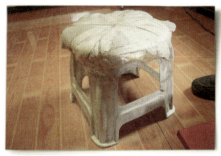

智果
The Fruit of Knowledge

食物以及财物,是诞生之初自然所供给的两个基本要素。人类将其占有的同时,认知也随之贪婪。大自然用其长盛不衰之美,鼓励人类与它同行,成为天地间的造物者。此刻,他试图从伪装者中辨出真伪,辨出那死物中的生机。那二者,享有彼此的称谓,状似孪生,彼元素在光明中生长,予以食用;此元素在黑暗中生长,予以长存。不过,当第三个元素出现,并将二者编织,凋零而持久的美,这一真实的面孔,便会随着一切缓和的认知、热情的创造浮出水面。

两种性质、功能完全不同的物质,一种是食物,另一种是石头,结合在一起,产生了不可思议的微妙联系。

在汶川羌人谷的调研中发现,当地山体岩石中镶嵌着大大小小的黑褐色石头,这种石头有点像宝石又有点像石榴籽。于是便询问当地居民,居民告知这是当地特产的矿石,因其与石榴籽的形状、颜色十分相似,故名"石榴石"。石榴石的英文名称为"Garnet",由拉丁文"Granatum"演变而来,意思是"像种子一样",而这个词可能由"Punica Granatum"(石榴)演变而来。

将石榴石从岩石层中收集起来,清洗后按形状大小分类,将石榴和石榴石放在一起,形成了一种大小、形状相似的联系。将石榴籽与石榴石"真假互换",重新编织在了一起,石榴石变成了"大地的石榴籽",石榴籽在石榴石的衬托下变得更加鲜艳夺目,新的融合、新的对比在此完美结合。

Since the beginning of time nature provided two essential elements: sustenance and wealth. Man seized them, and with knowledge came greed. The beauty of ever thriving nature encouraged man to become a creator likewise. Now he is trying to discern real from fake. The living from the dead. Two things share the same name and act like one. One grown in the light, one in the dark, one to eat and one to keep. But only a third element weaves them together, showing the true face of all cooling knowledge and warming creation: Withering, yet lasting Beauty.

Two substances with completely different properties and functions, one is food and the other is stone, combined together, creating an incredible subtle connection.

In the investigation of the Qiangren Valley in Wenchuan, the author found that the local mountain rocks are inlaid with large and small dark brown stones, which attracted the author's attention. She thinks this kind of stone is a bit like a gem and a bit like a pomegranate seed. So they asked the local residents and told them that this is a local specialty ore, which is named "garnet" because it is very similar in shape and color to pomegranate seeds. The English name of garnet is Garnet, which is derived from the Latin "Granatum", which means "like a seed". It may come from "Punica Granatum" ("pomegranate", or pomegranate).

The garnet is collected from the rock layer, and after cleaning, it is sorted by shape and size. The pomegranate and the garnet are put together to form a connection

of similar size and shape. The pomegranate seed and the garnet are "exchanged between the true and the false" and re-woven together. The garnet becomes the "pomegranate seed of the earth", and the pomegranate seed becomes more colorful and eye-catching under the background of the garnet. The new fusion and the new contrast are perfectly combined here.

Elisabeth Holzinger

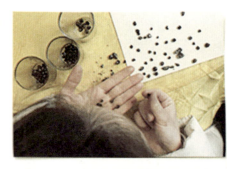
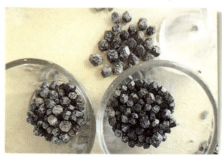

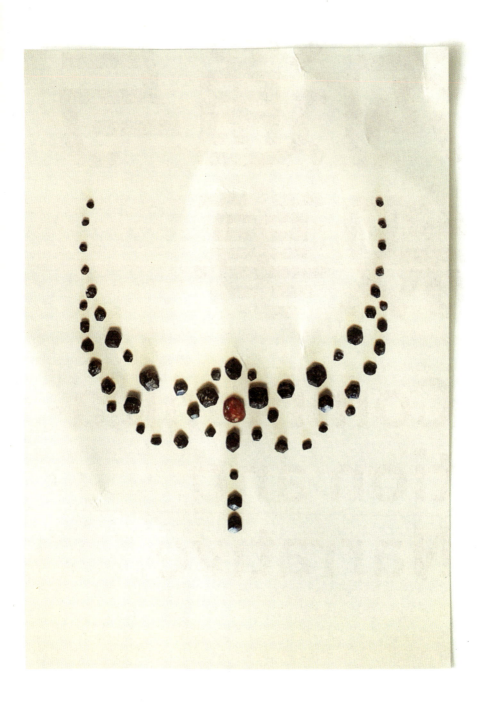

沟通与叙事

Communication and Narrative

II-VII

火炉与手机
Stove and Mobile Phone

羌秀
Qiang Show

述行绘图
Performative Drawing

火炉与手机
Stove and Mobile Phone

作品《火炉与手机》运用非虚构叙事方法手段，以视频画面显示现实世界，强调真实的声音，尝试描述和反思过去与现在的链接。

通过当地居民不同的火炉谈话场景，解读火炉、手机等物件传递出乡村振兴的转变。过去链接家人的是火炉，现在链接家人的是手机，通过作品发现乡村居民的智慧与生活的变化，引出不同观者对谈话内容、场景、乡村变化的思考，探讨乡村智慧的话题。

在作品《火炉与手机》的采访中，艺术家特意穿着羌族传统服装参与到采访拍摄场景中，目的是让被采访者不再视艺术家为局外人，也是希望唤起村民对自身民族文化的个人记忆，探讨继承与发展的可能，同时艺术家从当地居民的视角出发，更容易了解当地的文化生活，从而达到如实记录，达到客观真实的表现，同时也能帮助研究者避免因文化差异而造成对当地生活的误读与曲解。

作品创作过程中，重点选取有火炉的四类场景，有火塘的祖屋，有木炭火炉和柴灶的地震前旧屋，以及使用电炉取暖的新式村居，透过围炉谈话，围绕火炉、手机、亲情沟通链接话题，引出不同家庭与亲人的沟通联系，反映历史与家庭结构的变迁。采访中也注意到了村民日常生活中运用生活智慧解决实际问题，如动态巧用空间、自制生活和生产用具的多种细节。

采访影像是参与式影像工作中的重点环节，通过采访记录当地居民的日常生活情景，强调当地居民的参与和互动。采访则注重真实性，作品成果内容与客观事实严谨符合。过程中主要让受访人述说，然后把这些内容组合进作品主题的框架中，利用摄像机做客观记录，并以视频为媒介把故事最终讲述出来。

采访者以参与者和目击者的身份介入，对采访的形式和访谈的空间环境，事先都做过认真的选择和设计，多次到被采访的村民家中聊天，细心敏锐地观察被采访者的家庭环境、人员，了解家庭收入、工作、生活等信息，为后面拍摄采访内容做好准备。

在过程中采用参与式态度和方法融入整个过程中，努力把自己变成采访场景当中平等的主角，多用"我们""咱们"这类词语拉近距离，主动做换位思考，站在受访对象的角度围绕主题，逐步取得对方信任并力求融为一体，使气氛放松又活跃，也能获取更多的细节。

邱健敏

The work Stove and Mobile Phone uses non-fiction narrative methods to show the real world with video images, emphasizing the real sound, and trying to describe and reflect the link between the past and the present.

Through the different stove conversation scenes of local residents, the interpretation of stove, mobile phone and other objects conveys the transformation of rural vitalization. In the past, the family was linked by stove, but now the family is linked by mobile phones. Through the works, the wisdom and life changes of

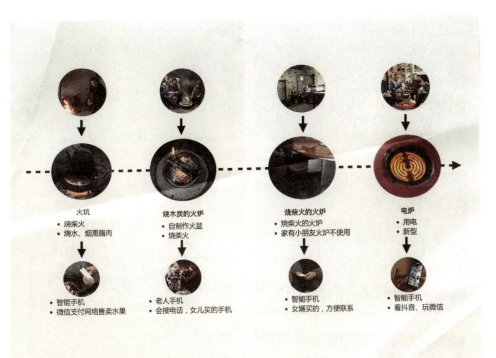

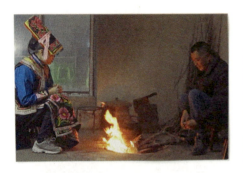

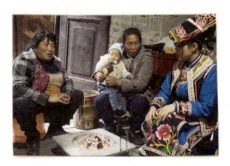

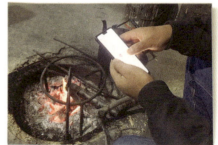

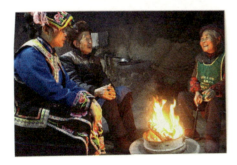

rural residents are discovered, which leads different viewers to think about the conversation contents, scenes and rural changes, and discusses the topic of rural wisdom.

In an interview of Stove and Mobile Phone, the artist deliberately dressed in Qiang traditional clothing to participate in the interview shooting scene, which made the interviewees not to regard artists as a outsiders, also hope to arouse the villagers personal memories of their own national culture, explore the possibility of inheritance and development, meanwhile the artists started from the vision of local residents, so as to understand the local cultural life easier. In this way, it can record the local life faithfully and give an objective and true performance. At the same time, it can also help researchers avoid the misinterpretation and distortion of local life caused by cultural differences.

In the creating process of the work, selected the four types of key scenes by the fires, which included the ancestral home, a charcoal furnace and tabun ovens old house before the earthquake, and the new village house using of electric stove, through the conversations by the stoves, around topics of the stoves, mobile phones, the family communication links, which led to the different families and relatives of communication, reflected the history and the change of family structure. In the interview, we also noticed that villagers use life wisdom in daily life to solve practical problems, such as dynamic use of space skillfully, self-made life and production tools in various details.

Interview video is the key link of participatory video researching, through which the daily life of local residents were recorded and the participation and interaction of local residents were emphasized. The interview focused on authenticity, and the contents of the work were in strict accordance with the objective facts. During the process, interviewees were mainly asked to tell stories, and then these contents were combined into the theme frame of the work. Objective records were made with cameras, and the story was finally told through videos as the media.

Interviewers involved in as a participants and witnesses of interviews, including the form of interviews and the environment of the conversation had seriously selected and designed before, by chatting with villagers for several times at their home, carefully observed the information such as environment, members, incomes, jobs, and life of the interviewees, to prepare for the contents of the interview later.

In the process of interviews, participatory attitudes and methods involved into the whole process, tried to turn myself into interview scenario equally, used words such as "we" , "let' s" to close distance, thought in an exchanging position positively, stood in the angle of the respondents around the theme, gradually acquired the trust by each other and strived to be in organic harmony, made the atmosphere relaxed and active, so as to get more details.

Qiu Jianmin

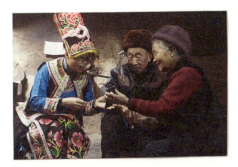
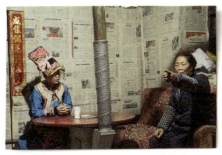

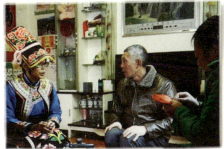

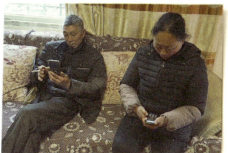

羌秀
Qiang Show

我们用"羌秀"直播的方式来介绍我们在东门寨的发现,通过现场表演,我们向大家展示了场景之中与之外的故事。其中一期内容为《移动—搬运—堆叠》的视频中,被拆毁的房子的石头躺在一堆碎石上,它们被装进篮子里。表演者背着装满石头的篮子,穿过休耕场地,然后经过遗留的家具,走过碎石路,接着通过封闭的道路,穿过覆盖着碎石的混凝土结构,最终,篮子里的石头被倒在同一堆瓦砾上。同样的事件和路径又重复地开始了。移动、搬运、堆叠,不断重复地工作。

We used "Qiang Show" live broadcast as the media to show our discovery in Donmenkou village. Through live performances, we showed the story of the scene and beyond.One of the show was called "Carry – Remove – Apply".In the video, stones from a demolished house lying on a heap of rubble. They are loaded into carrying baskets. The performers carry them over the fallow ground,past furniture left behind, up the gravel road,along a closed road and through a concrete structure covered with rubble. The baskets are emptied on the same pile of rubble. The path begins again. Carry, remove, apply. The senselessness of work.

Kerstin Reyer, Theresa Muhl, Sophie Netzer

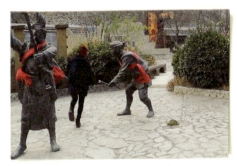

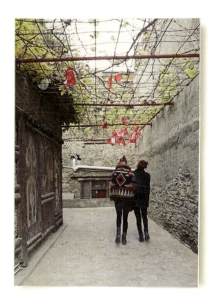
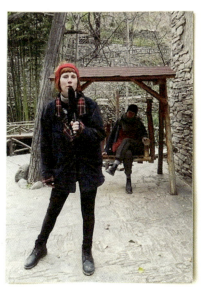
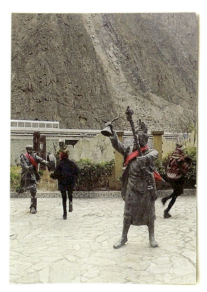

# 述行绘图
Performative Drawing

基于述行都市主义，我以手绘的艺术形式参与到村落社会现实和生活空间，让随机的观看视角和田野调研的交谈都参与到画面的建构过程中。我创制并持续地在奥地利和中国的村落实施这种"述行绘图"，在同一幅画面中最大限度地呈现村落整体布局、街道双侧的特定轴测图景和村户院落的情景细节。"述行绘图"也是我当下的博士研究课题。全球持续的城市化进程，伴随着的可能是村落人口和村落智慧的共同流失。通过多维透视线描画介入、认知和记录村落，特别是村落集中的居住空间，为我们和新生的城市原住民，建立一幅事无巨细的当代村落图像文本。

郑娴

Based on Performative Urbanism, I participated in the social reality and daily life space of village in a hand-drawn art form, allowing random viewing perspectives and conversation in field research to participate in the construction of the picture. I created and continued to implement the "Per- formative Drawing" in the village of Austria and China. The drawing features the overall layout of the village, specific axonometric views on both sides of streets, the details of courtyards and houses, etc. "Performative Drawing" is also my current doctoral research topic. The continuous global urbanization may be accompanied by a common loss of village population and also village intelligence. Through multi-perspective line drawing, to research and to record village life in the global community, especially the concentrated living space, creates a micro-detailed image text of the contemporary village for me as third-generation migrant worker and the new urban aborigines.

Zheng Xian

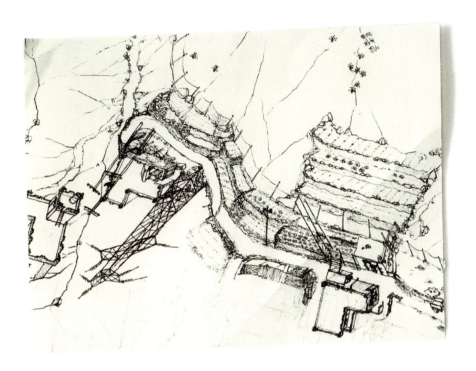

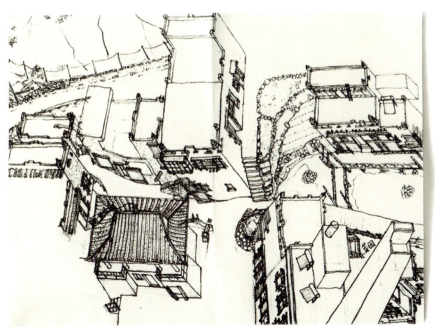

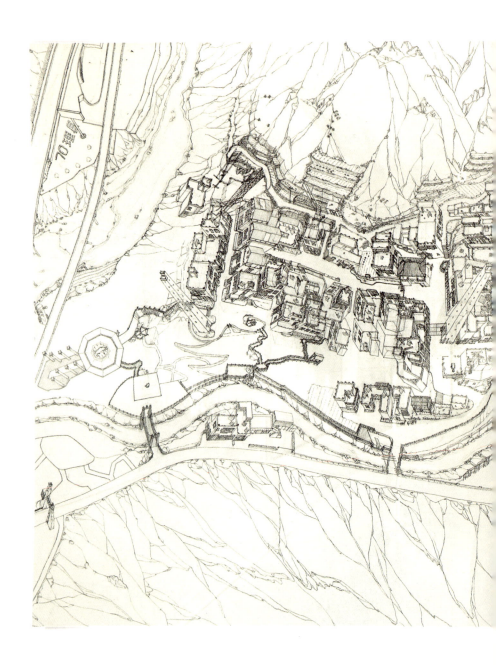

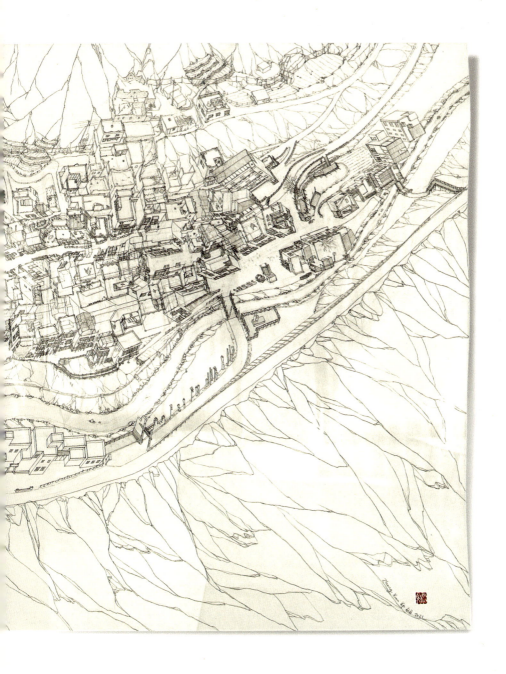

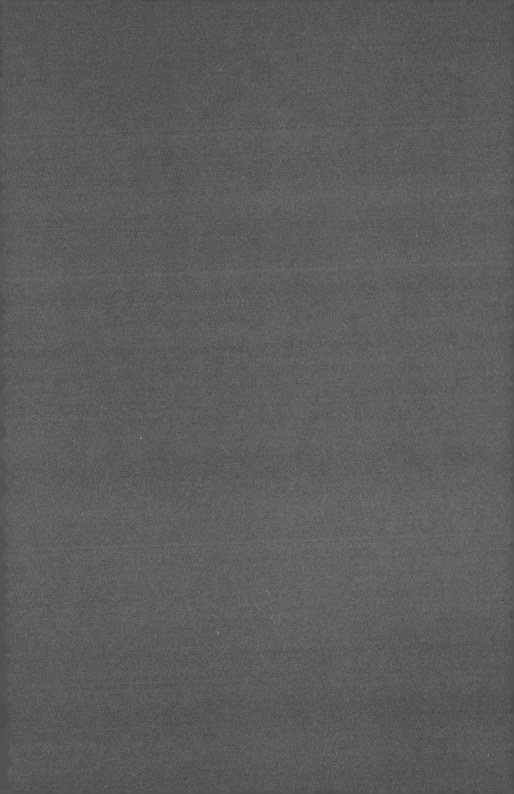

四个展览和两次巡游

III-I

Four Exhibitions and Two Parades

东门寨展览
Dongmen Village Exhibition

我们将参加深双展的展览空间置换于村落之中。村民和团队成员每天利用这个空间进行日常活动,我们以影像和照片的形式记录下这个过程。在最后一天的展览开幕式中,所有的乡村日常情景转化成了展览的内容,展览与乡村互相转化、融合。

背景 展览将作为一种背景出现在我们村里的活动之中。为了减少对村中环境的破坏,展览背景布利用村中的几棵树和房屋的结构,用麻绳吊挂在了广场的一个角落。受限于打印尺寸,展览背景分开两片吊挂;场地风非常大,因此在布的底部用石头增加了重量,减小布的摆幅。后来,为了在场地中获得更多的联系,展布的中央开了一个窗。

展厅 在展览背景之下,村中这个小广场成了村中生活的"展厅"。村民在"展厅"中搭建炉子,用硫磺熬制石硫合剂,用来涂抹樱桃树,预防病虫害。"展厅"中还呈现了村民的收获仪式——杀年猪,载歌载舞的夜晚——篝火晚会,旅行者的午餐——户外午餐,学生们的创作——灼热的石头、儿童的绘画……

展览开幕 工作坊的第一阶段在东门寨顺利结束,展览的开幕仪式,同时也是工作坊第一阶段的闭幕仪式,在展览背景前进行。唐叔作为村民代表为所有人准备了羌红,羌红作为羌族人民的礼物献给了大家。羌红,代表了吉祥如意、消灾辟邪的用意。Ton再次打开了他移动的黑板,用中文的谢谢表达了对大家付出的感谢,杨一丁也为整个阶段做了致辞。参加活动的还有专程赶来参加活动的荷兰领事馆领事 Bertrille Snoeijer。

The exhibition space of which we were going to exhibit in the UABB displaced in the village. Villagers and team members used this space for daily activities every day, and all these were turned into the content of exhibition along with the opening of our Dongmen village exhibition. The exhibition and the contryside exchanged and intergrated.

The Background In order to minimize the damage to the village environment, the printed canvas was hang on trees and house structures. Due to the limitation of the printing size, the canvas were hang separately. Moreover, the wind is very strong, so stones were added at the bottom of the fabric to reduce the swaying. In order to gain more contact in the site, a window was opened along the grid of the canvas.

The Exhibition Space The small square in the village becomes the "exhibition space" of village life. In the "exhibition space", villagers set up stoves to boil sulfur into a mixture, which was used to daub cherry trees and prevent pests and diseases. "Exhibition space" also presents villagers' harvest ceremony—pig slaughter, singing and dancing night—bonfire party, travelers' lunch—outdoor lunch, and students' creation—burning stones, children's painting...

The Ceremony The opening ceremony of the exhibition, which was also the closing ceremony of the first stage of the workshop. Uncle Tang as a representative of the villagers prepared qiang red, as the gift of the Qiang people to everyone. Qiang Red, represents good luck, the elimination of disaster and evil intentions. Ton opened his moving blackboard again and expressed his appreciation for everyone's efforts in Chinese thanks. Yang Yiding also showed his gratitude to everyone. Bertrille Snoeijer of the Dutch Consulate, who had made a special trip to attend the event.

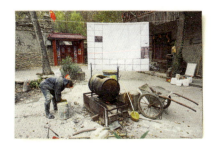
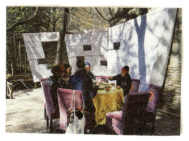
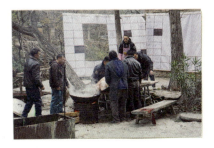
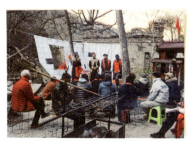
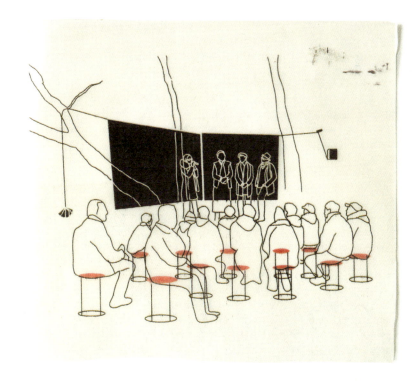

东门寨巡游
Parade in Qiang Village

在这次工作坊中,行为本身就是研究的内容。我们在东门寨中进行了一次大巡游,这次巡游具有多重意义。首先,巡游的起点是几位奥地利学生的作品"临时博物馆"展品的回归原位,巡游成了一个博物馆消失的一种仪式,同时也是我们展览开幕式的一个重要的环节,让大家回到展览的核心区域,开始开幕式。这个巡游也成了我们与村落的一次清晰的连接与结合,并用视频记录了下来,行为与空间发生了融合。

临时博物馆 这是三位林茨学生的发现与创作,他们通过对村落各个角落的探索,发现了许多有特点的物件。并通过再创作,把不同物件进行了组合,在一个闲置的空房间中设计了这些物件的位置,形成了一个临时的博物馆。这个博物馆的展品与展览让我们发现了一些不起眼的日常物件的独特性,以及空间本身的独特性。

搬运的巡游 搬运物件是一件本来就要做的事情,而在工作坊中,这件事情本身与研究的内容进行了结合,形成了一个对于时空的独特理解。什么是空间的体验?通过搬运巡游,我们把从村子不同场地中收集回来的物件进行了回归原位,并通过带着属于村里的物件,我们进行了一次不一样的村落空间体验,我们共同走过了熟悉的村道,并发现了这些平常的物件所在的不同地点,用一种全新的视角观察了村落的空间与文化。

In this workshop, behavior itself is the subject of study. We had a big parade in the Qiang village, which was of multiple significance. First of all, the starting point of the parade was the return of the "temporary museum" exhibits of several Austrian students' works. The parade had become a kind of ceremony for the disappearance of the museum, and it was also an important link of the opening ceremony of our exhibition, so that everyone can return to the core area of the exhibition and start the opening ceremony. This parade also became a clear connection and combination between us and the village, which was recorded by video, integrating behavior and space.

Temporary Museum This is the discovery and creation of three Linz students. Through their exploration of every corner of the village, they found many distinctive objects. Through re-creation, different objects were combined and the location of these objects was designed in an empty room, forming a temporary museum. The museum's exhibits and exhibitions allowed us to discover the uniqueness of obscuring everyday objects, as well as the uniqueness of the space itself.

Carrying Parade Moving objects is an inherent task, but in the workshop, this task itself was combined with the research contents, forming a unique understanding of time and space. What is the experience of space? By carrying a parade, the objects we collected from different places of the village returned to their original position, and through taking the objects belong the village, we had a different experience of village space, we together through the familiar village road, and found the common objects in different locations, observed space and culture of the village in a whole new perspective.

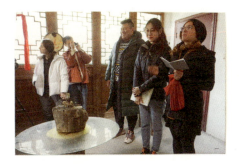
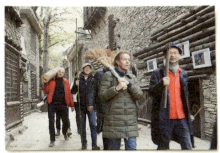
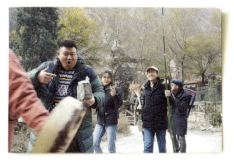
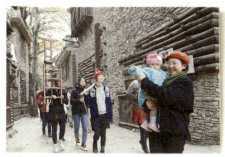
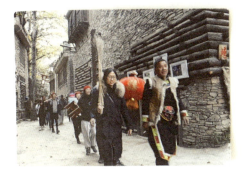

汶川少年宫交流
Wenchuan Children's Palace

在羌人谷进行调研的过程中，汶川政府特别组织当地儿童与我们进行交流。两校师生中的一部分人来到汶川县博物馆，在参观完博物馆后带领小孩写生县城的景色，看岷江湍湍流过，西北的羊龙山上香火烟起，记录下震后十年汶川的样子。

拓画 面对冬日的严寒，我们通过拓画的方式鼓励孩子观察环境，温暖身体。拓画是指使用实物作为摹本，采用拓的技法制作的图案或图形。孩子们主要选择周边有凹凸的物体作为拓画摹本，比如有纹理的石块、有花纹的地面铺装等。

速写 我们引导小孩以仔细观察和创造性的视角去看周围的环境，面对岷江对岸的山、天空的白云、人工的亭廊、花池里的植物等实景，并不是倾向于照相机式的模仿，而是通过速写表达一种新的语言，类似于用简单的线条、纹理作为记号的速记。在于找到居于最显著位置的意象，表达它，同时放弃其余的，用孩童的绘画语言快速记录看到的片刻。

拼贴 有些小孩更擅长手工创作，比如在行走的途中捡起树叶和石子等。通过素材拼贴的方式能让他们表达出更多的艺术想法，因此借助他们捡到的素材，通过不同材料拼贴的方式表达出看到的场景。

During our research in Qiang Village, the Wenchuan government specially organized a meeting with the local children from the Wenchuan Children's Palace. We visited the Wenchuan County Museum, after which we led the children to make sketchs and drawings of the scenery of the county, the marvelous landscape of Minjiang River and the Yanglong Mountain in the northwest, and the reborn Wenchuan ten years after the earthquake.

Printing For keeping warm in the cold winter, we encourage them to observe the environment by printing the patterns they found in the site. Printing drawing refers to make a copy of the real objects by pencil and paper to produce patterns or graphics. Children mainly choose objects with concave and convex edges to copy, such as the textured stones, the patterned pavement and so on.

Sketches We guided the children to watch carefully and creative perspective to the surrounding environment, in the face of the real scenes such as mountains opposite to Minjiang river, the white clouds in the sky, the other side of the mountain of artificial pavilion gallery, plants in flower beds, is not inclined to the imitation of camera type, but rather through a new language of sketch, similar to the use of simple lines, texture as a shorthand notation. It's about finding the image that dominates, expressing it, and abandoning the rest, jotting down the moment in the child's painting language.

Collage Some children are better at creating things by hand, such as picking up leaves and stones as they walk. They can express more artistic ideas through collage. They can express their images and ideas through the collage of different materials they picked up nearby.

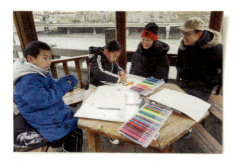
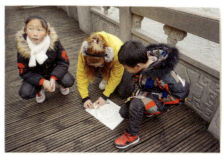
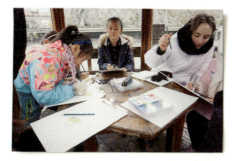
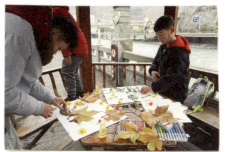
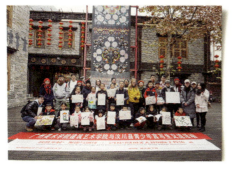

深圳雕塑院展览
Shenzhen Sculpture Academy Exhibition

工作坊的第二阶段，两校师生共同借用了深圳雕塑院的空间进行展览内容的最终制作。在深圳雕塑院，同学们进行了视频的剪辑，通过影像作品呈现研究叙事，并利用雕塑院现有的空间内容，进行了自己展览的设计，为自己的展品寻找合适的展示场景，进行了展览内容的后期创作。最终，东门寨的研究与展览在深圳雕塑院进行了第一次演绎。

工作场地 深圳雕塑院是工作坊第二部分的工作场地，老师们和同学们在这里完成了展览内容的最终制作。深圳雕塑院的展厅空间错层丰富，为成果的制作、展品的展示提供了满足多元化需求的场地。

放映会 深圳雕塑院的展览以一场放映会开始，放映会播放了同学们在工作坊期间制作的影片，通过视频叙事的方式呈现了工作坊的研究与发现。

颁发证书 放映会之后，老师们为学生们准备了工作坊结业证书，颁发的过程也是工作坊的必备仪式，在展厅里展开。

展览开幕 深圳雕塑院展览的开幕式别出心裁。因为，在展览开幕之后，奥地利师生就要回国了。开幕式中邀请了舞狮团队来传递中国传统的仪式感，而开幕酒会的食物则是由老师们和同学们共同到街边包子铺等小吃店购买，并通过蒸笼容器亲自从店铺带回。大家围在展厅酒吧前聊天、吃包子、喝酒，这是一次在彻底的放松状态中的享受。

In Shenzhen Sculpture Academy, the students made video clips, presented research narratives through video works, and designed their own exhibitions by using the existing space contents of the Sculpture Academy, looking for appropriate display scenes for their exhibits, and carried out the later creation of exhibition contents. Finally, the research and exhibition of Dongmen Village was performed for the first time in Shenzhen Sculpture Academy.

Work place The Second part of the workshop took place in Shenzhen Sculpture Academy, where the teachers and students completed the final production of the exhibition contents. The exhibition hall of Shenzhen Sculpture Academy is rich in split-level space, which provided a place to meet diversified needs for the production of achievements and the display of exhibits.

Screening The exhibition began with a screening of the films made by the students during the workshop, presenting the research and findings of the workshop through a video narrative.

Certificate After the screening, the teachers prepared the workshop certificates for the students, and the awarding process was also the necessary ceremony of the workshop in the exhibition hall.

Vernissage The vernissage for the exhibition of Shenzhen Sculpture Academy was special, because after the opening of the exhibition, the Austrian students would return to Europe. A lion dance team was invited to the opening, a very traditional ceremony in China. The food for the party was also specially delivered, which was bought by the teachers and students in their own steamer containers from snack shops on the street with the dancing lion. Everyone gathered around the bar in the exhibition hall to chat, eat, drink, and relax.

深圳巡游
Shenzhen Cruise

在深圳雕塑院所在的街区邀请了醒狮团队一起联欢，庆祝工作坊圆满结束的同时，再次以广东特色的巡游方式与周边商铺店主顾客进行互动，使原本被市政施工影响的生意情境得以暂时恢复热烈。

舞狮 Ton和杨一丁将"醒狮"文化的表达作为深圳展览的开幕。舞狮是岭海民间千百年不断流传广泛、内涵丰富、群众喜爱的传统技艺，每逢节庆或有重大活动，必有醒狮助兴，长盛不衰，历代相传。通过舞狮的精气神为本次工作坊学生付出的努力给予认可和鼓舞。

食物的巡游 岭南文化中对食材的应用也极具特点，正如广州的文化，融汇古今，贯通中西，形成了有别于国内其他地区、独具特色的广州饮食文化，因此有了博采中原美食和西餐之长，再吸收广东境内陆方菜优点的粤菜，名扬海内外。因此在进入深双展览之前，两校师生共同沿着深圳雕塑院周边的道路进行食物巡游，每个人手中拿着即刻从路边商铺买到的食物，与路人互动，与这个城市进行交流。

In the block where Shenzhen Sculpture Academy is located, the Lion Dance team was invited to have a party to celebrate the successful completion of the workshop, and at the same time, they once again interacted with the shop owners and customers in the surrounding area in a Parade with Guangdong characteristics, which temporarily restored the business situation which had been affected by municipal construction.

The Lion Dance Ton and Yang Yiding opened the UABB exhibition with the expression of "Lion Dance" culture. Lion dance is a traditional art that has been widely spread and popular among people living in coastal area of southern Guangdong for thousands of years. It is a traditional art that is popular with the masses and has rich connotations. Through the spirit of the lion dance to recognize and encourage the efforts of the students in this workshop.

Food Parades The application of food materials in Lingnan culture is also very characteristic, just like the culture of Guangzhou, which combines ancient and modern, connects the east and the west, forming a unique Guangzhou food culture that is different from other parts of China. Therefore, it has the advantages of absorbing central China's cuisine and western cuisine, and then absorbing the advantages of mainland cuisine in Guangdong, which is famous in domestic areas and foreign countrys. Therefore, before entering the exhibition, the teachers and students of the two universities conducted a food parade along the road around the Shenzhen Sculpture Academy. Each student held the food that he or she immediately bought from the roadside shops in his or her hands, interacting with passers-by and communicating with the city.

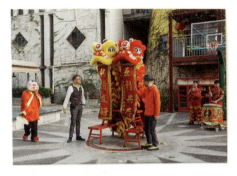
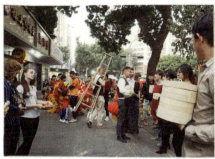
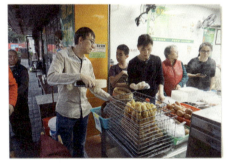

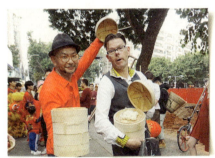

深双展览
Shenzhen Biennial Exhibition

在深双展福田车站主展场被压缩的略显局促的展位里,我们以多屏方式循环播放编辑制作后的作品视频,并摆设了从现场带回的水果、各式生产生活用具和座凳,营造了亲切动人的沉浸式体验,也为观众提供了短暂歇息、耐心观看的可能。

布展 由于深双展在工作坊开始之前就要求我们提供展场设计,我们的布展反而变得轻松了。按照计划,最初展厅的设计内容贴在了空间的不同界面上,并按照计划把电视和投影的位置固定,将最终制作的视频分类放在了三个放映区域;同时,从东门寨带来的实物也放置在了展场中,以营造现场感的场景。

访谈 展览开幕的当天,杨一丁接受了深圳电视台的采访。采访中,杨一丁提到了这次展览的策展初衷和工作坊的过程,这些内容都源自于广州美术学院的教学研究的兴趣以及和林茨艺术大学合作所碰撞出来的思想火花。

交流 展览中,我们与许多参观者进行了交流。很多参观者对木锁非常感兴趣,也通过实物进行了开锁的尝试;有很多参观者在现场品尝了汶川东门寨的苹果,并通过微信进行了购买;参观者在我们的展区里聊天,坐在我们从东门寨带回来的凳子上,并呈现出围坐在火炉旁聊天的场景。

记录 我们在现场拍摄了一段视频,记录了参观者的状态,以及每一个参展老师和同学的感受,作为工作坊在深双展厅的一次再演绎和结束。

In UABB, the station mastered the show compressed slightly cramped in the booth, we played the edited videos in loop on the multi-screens, and decorated fruits took from the site, all kinds of production and living appliances and stool, build a warm and moving immersive experience, also gave the audience a brief rest patience to watch.

The exhibit Since UABB asked us to provide the exhibition design before the workshop started, our exhibition layout became easier. According to the plan, the contents in the exhibition was printed on different interfaces of the space, and the final videos were classified into three screens. At the same time, objects brought from Dongmen Village were also placed in the exhibition hall to create a sense of scene.

Interview On the opening day of the exhibition, Yiding received an interview from Shenzhen Television. In the interview, Yiding mentioned the original intention of the exhibition and the process of the workshop, which are all derived from the coorperation of GAFA and University of Art and Design Linz.

Communication During the exhibition, we communicated with many visitors. Many visitors were very interested in wooden locks and tried to open them through physical objects. Many visitors also tasted apples from Qiang Village in Wenchuan and bought them through we-chat. Visitors were chatting in our exhibition area, sitting on the stools we brought back from the Qiang Village, and presenting the scene of chatting around the fire.

Record We shot a video at the site to record the state of the visitors, as well as the feelings of each teacher and student as a re-interpretation and conclusion of the workshop in the UABB Exhibition Hall.

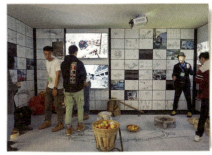

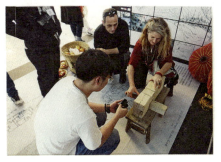

广美展览
GAFA Exhibition

在广州美术学院建筑艺术设计学院的宽阔展厅中，更以生动多样、转化重现的手法，创造了一个趣味性与学术性高度融合的汇报展览，部分陈列内容至今仍然保存在展厅里，为后续师生反复观看学习保存了一条延续的线索。

布展 这次展览是对村落展览、UABB展览的进一步延续，利用校园的优势，将工作坊成果"发现——演绎——延续"。我们用与东门寨展览一样的防水布打印了村中的"展厅"，也是UABB的展厅，并将我们拍摄的视频展示于此；我们把研究整理成大幅海报，考虑到不影响人对空间的使用，我们设计了横向尺寸的海报，并运用了醒目的字体和大的图片，将海报高挂在展厅中；我们还把我们从东门寨带回来的实物展示在展厅之中，并用黄色胶带纸对其进行范围的标注，并标上名字和故事；我们用泡沫场地模型标注了我们所有的考察点；我们还打印了许多人物、草图和事件，贴在展厅中的玻璃、墙面和地面上，为展厅增加现场感和画面感。

展览 学院的院领导、老师们、同学们以及业界的朋友们共同参加了广州美术学院展览的开幕仪式，并对智慧乡村主题进行了多层次的探讨。参观者可以通过实物触摸到乡村的"智慧"，也可以通过时间线了解整个工作坊的过程，草图的展示提供了大家最初的想法，模型呈现了村落的整体面貌，视频提供了直观的现场画面与叙事，吊挂的海报表达出研究的主题。由于展览设计延续了在东门寨的展览布置理念，即对空间场地的最小化影响，因此，展览的海报、贴纸等内容至今一直延续存在于学院展厅之中。

In the wide exhibition hall of the School of Architecture and Applied Arts in Guangzhou Academy of Fine Arts, we created an interesting and academic report exhibition with vivid and diverse methods of transformation and reproduction.

The Preparation of Exhibition This exhibition was a further continuation of the Qiang village exhibition and UABB exhibition. We printed the "exhibition space" in the village with the same waterproof cloth of the UABB exhibition, and displayed the video we shot here. The research topics were shown in large posters. Considering that it would not block the daily use of the space, we designed posters with landscape format and used eye-catching fonts and large images, hanging in the space. We also displayed the objects we brought back from Qiang Village, and marked them with yellow tape, names and stories. A site model of Qiang Village marked all the points we inspected. Lively images of the village and people was pasted.

The Exhibition Teachers, students and friends attended the opening ceremony. Visitors can touch the "wisdom" we found in the village, and glance at the process of the workshop through the timeline. Sketches provided initial ideas, models showed the architecture entity integrity, videos unfolded stories and narratives, and hanging posters presented the topics of the research. Similar to the concept of exhibition layout in Qiang Village, which is to minimize the impact on the site, the exhibition contents has been continued in the exhibition hall of GAFA until today.

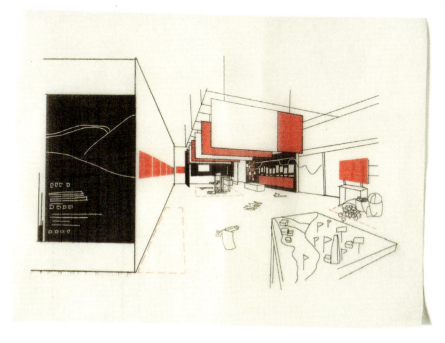

193

时间线
Timeline

Ⅲ-Ⅱ

2019.11.26-1.27

系列讲座
SERIES OF LECTURES

2019.11.28-12.08

参观村落
VISIT THE VILLAGE

物件故事
OBJECT STORY

开展调研，发现智慧
CARRY OUT RESEARCH

绘画行动
PAINTING ACTION

参观地震博物馆
VISIT EARTHQUAKE MUSEUM

羌寨剧场 + 杀猪日
QIANG VILLAGE THEATER

| 2019.12.08-12.15 | 2019.12.20-12.21 | 2019.12.23-27 |

资料整理
DATE COLLATION

开幕预热
PREHEATING OF OPENING CEREMONY

深双展开幕
UABB CEREMONY

广州美术学院汇报展
GAFA EXHIBITION

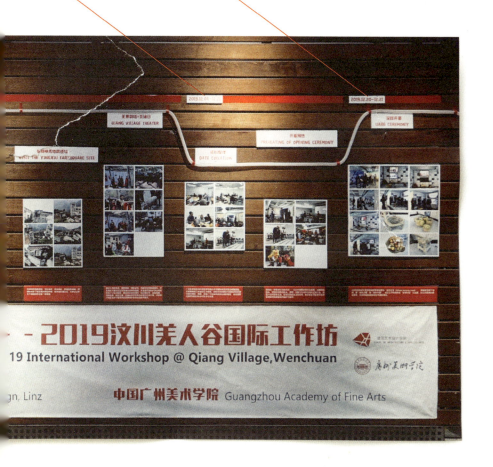

人物
People

pic.p-1
磊磊
pic.p-2
邱健敏
pic.p-3
唐成继
pic.p-4
郑娴
pic.p-5
Jana Simburger
pic.p-6
杨一丁
pic.p-7
Elisabeth Holzinger
pic.p-8
Rianne Makkink
pic.p-9
Pepi Josef Maier
pic.p-10
李薇
pic.p-11
温颖华
pic.p-12
王海鸥
pic.p-13
Bobbie Qiang
pic.p-14
陈桂玲
pic.p-15
潘泓
pic.p-16
黄辉
pic.p-17
林梓晟
pic.p-18
马旭龙
pic.p-19
续晓雪
pic.p-20
张沛彦
pic.p-21
何伟
pic.p-22
胡玥
pic.p-23
Bertrille Snoeller
pic.p-24
Kerstin Reyer
pic.p-25
Theresa Muhl
pic.p-26
Ton Matton
pic.p-27
Christian Schrenk
pic.p-28
Sophie Netzer
pic.p-29
Tobias Saatze
pic.p-30
Gwinner Florian Georg

一条叫波比的狗
A Dog Named Bobbie

在村里游荡,到处寻找吃的,
我很久没能吃东西了,

一个外国女人发现了我,
她从荷兰来,是个教授,名叫瑞安。
我跟着她见到了她的伙伴,
一群来自中国和外国的老师和学生,
在寨子里考察调研。

我很衰弱,
听他们吃饭时议论,
外国学生说我肯定是受到虐待,
应该找支猎枪杀死我,算是人道,
中国学生说我可能是和别人打架受伤,
应该让我保持现状,继续活着,
双方争执不休,也没有找到猎枪。

瑞安则仔细检查我的情况,
帮我拔除了卡在嘴里的骨头渣,
又买了药,治好了我。
于是,
我就继续活着。
粘着她和她的伙伴们,
在村里各处跑来跑去,
学着他们张望忙碌。

他们要离开了,
瑞安说要带我走,
去一个开着郁金香花的国家,
村里的人都说我命很好。

我跟着他们去了南方,
在他们的展览会上,
我总是被特别地介绍,

既像是来自寨子里的代表,
又是他们之中的一员。

世界疫病流行,我没有去成外国,
留在温暖的广州,
交替住在颖华老师的工作室,
和潘泓的学校,
瑞安来信说想念我,
并祝我幸福,
还说会找一个像我一样的朋友,
和她作伴。

我也有了很多新朋友,
有学校的学生和老师,
有设计师和小孩,
还有路上遇到人和小动物。

城市里很干净,
我要不停地撒尿,
好让自己融入这里的土地。

我特别喜欢这里的鸡腿,
吃完一个总会想,
下一个在哪里?

潘泓毕业工作了,
成了我的大哥,
有一天,
他特别从网上买寨子里的苹果,
让我又尝到了那种甜。

Wandering the village in search of food,
I haven't been able to eat in a long time.

A foreign woman found me,
She's from Netherlands. She's a professor. Her name's Rianne.
I followed her to meet her friends,
A group of Chinese and foreign teachers and students,
Exploring the village.

I was weak.
Listened to what they say at dinner,
The foreign students said I must have been mistreated,
You should get a shotgun and kill me, as a matter of humanity,
Chinese students said I might have been injured in a fight,
I should be allowed to live as I am,
There was an altercation, and no shotgun was found.

Rianne checked on me carefully,
Helped me remove the bone from my mouth,
She bought the medicine and cured me.
As a result,
I lived on.
Clinging to her and her friends,
Running around the village,
Imitating them to look busily.

They were leaving,
Rianne said she was taking me away,
Go to a country full of tulips,
People in the village said I was lucky.

I followed them to the south,
At their exhibition,
I was always specifically introduced,
Like a representative from the village,
And one of GAFA team too.

COVID-19 widely spread,
Instead of going to a foreign country,
I stayed in the warm Guangzhou,
Living in Yinghua's studio,
And Pan Hong's school,
Rianne wrote to me that she missed me,
And wished me happy,
She said she'd found a dog like me,
Keep her company.

And I made a lot of new friends,
There were school students and teachers,
There were designers and kids,
And people and animals on the way.

The city is very clean.
I have to pee all the time,
To integrate into the environment.

I particularly like the drumsticks here,
After one, I always think,
Where's the next one?

Pan Hong graduated and got a job.
He became my big brother,
One day,
He bought apples from the village on the Internet,
I taste that sweet again.

203

回声
Echo

III–IV

一切以人为本 智慧村落是一个灯塔式的超前项目，一个通过以不断地思想创新和学习实践来探知未来的项目。这个目标非常卓越，且魅力十足。

虽然现代社会我们必须依靠高新技术，但最终，一切还是以人为本。使我们不断创新前行并超越界限的，正是人的探索精神。

托马斯·斯泰尔策，上奥地利州州长

Everything is people-oriented Smart Village is a beacon project, a project to explore the future through continuous thinking in innovation and learning practice. This goal is remarkable and fascinating.

Although modern society must rely on high technology, in the end, it's all about people. What makes us innovated and transcended boundaries is the human spirit of exploration.

Mag. Thomas Stelzer, Governor of Upper Austria

国际友好城市结出的硕果 即使是在新冠肺炎疫情肆虐全球的危机时刻，我们也强烈地感受到，中国的朋友们是多么的可靠。他们快速高效地组织了一批急需的防疫物品，将其作为援助物资赠送给林茨市。

中奥两国在文化领域中的友好交流合作也同样历史悠久。"智慧村落SMART VILLAGE"项目为增进我们之间的相互了解，增加了一块重要的基石。

克劳斯·卢格尔，林茨市市长

The fruits of international sister cities Even at this moment of crisis when COVID-19 is ravaging the world, we are keenly aware of how reliable our friends in China are. They quickly and efficiently organized the urgent-needed shipment of quarantine supplies, which were presented to the city of Linz as aid.

China and Austria also have a long history of friendly exchanges and cooperation in the cultural field. The SMART VILLAGE project adds an important cornerstone to our mutual understanding.

Mag. Klaus Luger, Mayor of Linz

文化交流合作 林茨艺术大学的"智慧村落SMART VILLAGE"项目，完美地融入到了林茨与中国的中心城市群的合作项目之中。对于开展有利于双方的、富有价值的、可持续的文化交流合作，这个项目也是一个出色的范例。

朱利叶斯·斯蒂伯尔，林茨市文化局局长

Cultural exchange and cooperation The "SMART VILLAGE" project of University of the Art and Design Linz perfectly integrates into the cooperation projects between Linz and the central urban agglomeration of China. The project is also an excellent example of how valuable and sustainable cultural exchanges can be carried out for the benefit of both sides.

Dr. Julius Stieber, Director of the Cultural Bureau of linz

艺术院校的跨国学术合作 林茨艺术大学和广州美术学院的合作研究团队选择以述行研究的方式来调研中国的乡村生活,其研究结果表明,基于艺术手法的研究也能为保护和重新诠释农村地区做出重大贡献。"智慧村落SMART VILLAGE"项目是一个典范,它成功地向我们展示了现代社会如何从农村地区的研究中获得可持续性收益,其研究成果可为定制乡村地区发展新战略做出重大贡献。

布里吉特·赫尤特尔,林茨艺术大学校长

Transnational academic cooperation among art schools The collaborative research team from University of the Art and Design Linz and Guangzhou Academy of Fine Arts chose to investigate rural life in China in a declarative way, and their findings show that artist-based research can also make a significant contribution to the conservation and reinterpretation of rural areas. The SMART VILLAGE project is a successful example of how our modern society can derive sustainable benefits from research on rural areas, and its findings can make a significant contribution to customizing new strategies for rural development.

Mag. Brigitte Huttcr, President of University of the Art and Design Linz

智慧乡村?这并不是笔误 "智慧乡村,这是笔误吗?我觉得应该是智慧城市。"这是我2019年9月听到这个项目时的第一反应。"智慧"这个词我常常与大城市联系在一起,或者是高科技公司,或者是新兴公司,但不是村落。

这是一个在东门口村的十二月的周六,阳光明媚而寒冷,学生们汇报了关于智慧村落的发现和观点,这些发现涉及面极广,从收获苹果、取暖系统到农户椅子的设置。不同的观点正好反映了这群学生多元化的背景:不同的国籍、年龄、文化和学习背景。但他们都有一个共同点——他们都对在乡村做研究充满了兴趣。

我相信这次到访乡村不仅令我印象深刻,对整个学生和老师团队也一样:这令我们都对中国的乡村生活有了新的认识,同时也对我们自己有了新的认识。

贝特利尔·斯诺埃尔 荷兰驻重庆总领事馆副总领事

Smart Villages? It is not a typo "Smart Villages. Is it a typo? I am sure it should be Smart Cities." These were my thoughts when I first heard about this project last year in September. "Smart" is a word I usually associated with large cities, or high-tech companies and start-ups, but not with villages.

It was a sunny and frigid day, that Saturday in December in Dong Men Kou village. The students presented their findings on their specific views and interpretatiovns of Smart Villages. I watched and listened to a wide range of topics, from harvesting apples via heating systems to seating arrangements in a farmhouse. Different perceptions that were a perfect reflection of this diverse student group: different nationalities, ages, cultural and study backgrounds. But they all had one thing in common – they shared their enthusiasm on doing research in the countryside.

I am sure this visit has not only been an impressive experience for me, but also for the rest of the group: getting to know more about country life in China and about ourselves as well.

Bertrille Snoeijer, Deputy Consul General,
Consulate General of the Kingdom of the Netherlands in Chongqing

羌谷余音
Echoes in Qiang Valley

"凡乐,达天地之和,而与人之气相接,故其疾徐奋动可以感于心,欢欣恻怆可以察于声。"从美学的角度来看,一段旋律的编制能曲折地反映出复杂的社会生活与人的思想感情变化的关系,通过调动欣赏者的审美感受能力,唤起欣赏者内心的情感意象,才能产生喜、悲、歌、泣,手舞足蹈的艺术效果。只有造诣很深的乐师,细心领会,才能对之得心应手,"而不可述之言也"。音乐修养很高的听众,对于音乐也只能心领神会而不可言传。对于同样的一段音乐,不同的听者在不同的时间点所感受到的也不一样,所谓"仁者见之谓之仁,智者见之谓之智"。不同的人对同一事物因为其立场、方法、观点、知识背景、认识能力、实证过程都可能不同,因而认识的结果就会各不相同。可见,要创造出"乐",首先要有金石丝竹各种乐器,其次是能工善巧的乐师,再者是听众。这次甘孜阿坝州的羌寨之旅对我们来说是一场与天地享"乐"的参悟。

声音的很多来源在于物与物的接触。在阿坝州羌人谷的半月时间,我们的日常是讨论看到的景象和听到的声音,譬如当地的民族建筑、文化图腾、人们衣服的样式、高山云雾和影影绰绰的羊群、山上石头滚落的声音和水流的激荡等。

对于林茨大学和广美的师生而言,这里的所见都是新鲜的,值得去挖掘和讨论。我们为这片冬日安宁的寨子创造出了不同文化背景中言语的激荡,思想的火花,其中让我记忆尤深的是贴在寨子入口和公路上的标语、温顺的流浪狗波比、林茨大学教授ton、留学生、崖壁坠落的滚石、高耸入云的山峰、长得巨大的龙舌兰、沿途遇到的杀猪锅等。这些记忆点的人或物都是在一段段强烈的对比中留下来的。就像公路上的标语是在中国日常所见到的,无论走到哪里,我们都能在乡村中看到"优生优育,少生孩子多种树""相信党,相信人民"等类似的标语,一些林茨艺术大学的同学们从第一天到深圳看到张贴的大字就开始讨论。他们看不懂这些字,就像机场里贴的很多海报,写的字是"仁""礼"等,还有机场外的广场有庆祝建党活动的大字等,他们产生了很多的想法。当我们中国的学生知道后,笑而不语,文化是时间一点一滴注入血脉中的,对我们来说类似的标语无关乎内容,就是日常所见场景中的背景。这样的文化碰撞也不仅体现在对标语的态度上,还包括对待婚恋关系、饮食方式等方面,西方男女对立的或者说是女权思想,也是西方女大学生们日常交流的内容,这一点似乎东西方之间也在逐渐统一战线。西南冬季或者是说中国北方的很多乡镇,人们会在冬季寒冷的季节宰猪杀羊,这一幕也正好被我们看到,西方的朋友们为此感到震惊和痛苦,并为死亡的动物们祷告。他们很多人是纯粹的素食主义者,因而我们日常的餐饮也都是分为荤素两类,明白了他们是出于全球变暖的考虑,我们也对这些素食主义者肃然起敬。

我记得Ton来到寨子的第一天为我们上了一节课，他提到了两个字，第一个是"fake"。Ton告诉我们，你们所看到的，也不仅是在这里，在西方也是，很多都是假的。我又想起来那些标语，也可以用"fake"来理解。同比寨子里的建筑，有很多也是后来翻修的，包括很多羌人谷宣传的景点，也都是近几年建出来的。我感受到Ton想传递的是不要去相信眼睛所看到的，要去做出判断，真相不重要，态度更重要。第二个字是"debate"。Ton举起他的两只拳头撞到了一起，他希望师生之间可以辩论起来。但是很显然，不管是中国还是西方，师生之间的空间关系是趋于一致的，真正意义的"debate"并不多见，更多的是"communicate"。

除了很多不同的声音，中西方的师生之间也有很多共鸣，比如对美景的共识，对本地人生活智慧的赞叹，还有对我们的吉祥物"波比"的态度。波比的出现打破了我们彼此之间客气、陌生和弥漫尴尬的氛围，一条狗和一群陌生人之间搭建出了一个网络。我们都在感叹，这是一只很幸运的狗，瑞安是波比的贵人，帮它处理了伤口并计划带去荷兰，由此一只被游客遗弃的流浪狗很快要成为荷兰狗。虽然说因为疫情的原因，波比最后没有去成荷兰，但是它由我们中国的学生领养，在广州安家，成为广美建院研究生们的吉祥物。同样，波比的留下对我们来说也是这次旅程的一个音符，看到它，会想到寨子里的一切，关于达叔、村民、苹果、野山羊、溪谷和乡村展览。

"理国家，知兴亡"，这些也都是得乐之道者的作为。这样的调研也是我们在汶川震后十年对那里的寨子和人们生活的梳理。生活在这片热土的人都心系彼此，生活在羌人谷里的人们，他们日常要面临灾后留下的自然伤疤，路途躲避落石，也要面临西南偶发的小震。但是他们没有畏惧或者是不安，他们对变化做出调适，并且在政府的引导下创造了更适合当下的经济运作方式。我们在这次的拜访后也对我国政府有了更大的信心，乡村和城市的距离并不远，今天乡村的智慧不仅是本土村民在创造，也有政府的手和热心人士的力量，我们在一起营造智慧乡村。

何伟

"All music, could up to the sum of heaven and earth, and connected with the Chi of people, so its rapid and vigorous can be felt by hearts, joy side can be observed in the sound." From the aesthetic point of view, the composition of a melody can zigzag reflect the relationship between the complex social life and the change of people's thoughts and feelings. Only by mobilizing the aesthetic feeling ability of the appreciator and arousing the emotional image in the heart of the appreciator can it produce the artistic effect of joy, sadness, singing, crying and dancing. Only a musician of great attainments, careful understanding, can be handy to it, "and the words can not be said." Even the audience with a high level of musical literacy can only understand music without words but by heart. For the same piece of music, different listeners feel different at different points in time, the so-called "benevolence is what benevolence sees, wisdom is what wisdom sees." Different people may have different positions, methods, viewpoints, knowledge background, cognitive ability and empirical process on the same thing, so the results of cognition will be different. Therefore, in order to create "music", it is necessary first to have various instruments of metal, stone, strings and woodwind, then to have skilled musicians, and then to have audience. This trip to the Qiang Village in Aba Prefecture of Ganzi is an enlightenment for us to enjoy the "joy" of heaven and earth.

A lot of sound came from object to object after contacted. During the half month in Qiang Valley in Aba Prefecture, we discussed the sights and sounds we saw and heard, such as the local ethnic architecture, cultural totems, the patterns on people's clothes, the mountain clouds and shadowy goats, the sound of falling rocks and the agitation of the water.

For the faculty and students of Linz University of the Arts and GAFA, what was seen here were new and worth exploring and discussing. We created for this piece of quiet winter village agitate words in different cultural backgrounds, the spark of thought, which let me memorized deepest about was the signs on the village entrance and road, the tame stray dog bobby, Ton, a professor at the Linz University of the Arts, students, sparkling water falling, towering peaks, rolling stones, huge agave, killing pig pot met along the way and so on. The person or object of these memory points is left in a period of intense contrast. Just like the slogan on the highway which seen by Chinese everyday, everywhere in rural areas like "less birth more planting", "believe in the Party and the people" and so on, some students from the Linz University of the Arts saw big slogans posted on the first day in Shenzhen and began discussing. They can't read these characters, just like many posters posted in the airport, writing the characters of "benevolence" and "courtesy", and the square outside the airport has big characters celebrating the Party Founding activities and so on. They had more thoughts about the Chinese government. When we Chinese students knew this, we laughed without a word. Culture is infused into our blood bit by bit over time. For us, similar slogans are not about contents, but the background of the scene we see every day. Such cultural collision was not only reflected in the attitude of slogans, but also in the relationship between marriage and love, diet and so on. Western female college students' daily communication is also about the opposite of western

men and women or feminist ideas, which seems to be gradually united between the East and the West. In winter of southwest China or in many towns in north China, people would slaughter pigs and goats in the cold winter season. This scene was also witnessed by us. Our friends in the West were shocked and distressed, and prayed for the dead animals. Many of them are pure vegetarians, so our daily meals were divided into meat and vegetarian categories. Knowing that they are motivated by global warming, we are in awe of these vegetarians.

I remember when Ton gave us a lesson on the first day he came to the village, he mentioned two words. The first one was "fake". What you see, Ton tells us, not just here, but in the West, a lot of them are fake. And then I remembered the slogan, fake. Compared with buildings in the village, lots of them were later renovated, including many Qiang Valley publicity attractions, were also built in recent years. I felt what Ton wanted to convey was not to believe what the eyes saw, to make a judgment, the truth is not important, attitude is more important. The second word was "debate". Ton raised his two fists and banged them together. He hoped to have a debate between teachers and students. But obviously, no matter in China or in the West, the spatial relationship between teachers and students tends to be consistent. There are not many debates in real sense, but more communication. In addition to many different voices, there are also many similarities between Chinese and Western teachers and students, such as the common understanding of beautiful scenery, the admiration of the wisdom of local people's life, and the attitude towards our mascot "Bobby". Bobby's presence broke the polite, strange, awkward atmosphere between us, creating a network between a dog and a group of strangers. We all sighed, he is a lucky dog, Ryan is Bobby's savior, helped him to treat with the wound and planned to take him to the Netherlands, such a stray dog abandoned by tourists will soon become a Dutch dog. Although Bobby did not go to the Netherlands because of the epidemic, he was adopted by our Chinese students and settled down in Guangzhou, becoming the mascot of the graduate students of School of Architecture of Applied Arts, GAFA. In the same way, Bobby's stay is a note of the journey for us, reminding us of everything in the village as we saw him, about Uncle Da, the villagers, the apples, the wild goats, the valley and the country show.

"Managing the country, knowing the rise and fall", these are also the way of happiness. This kind of research is also our review of the village and people's lives in Wenchuan ten years after the earthquake. The people who live in the Qiang Valley have to face the natural scars left by disasters, avoid falling rocks, and face the occasional small earthquake in southwest China. But without fear or unease, they adapted to change and, under the guidance of their government, created an economy better suited to the present. After this visit, we also had more confidence in the Chinese government. The distance between the countryside and the city is not far. Today, the wisdom of the countryside is not only created by the local villagers, but also by the government and the power of enthusiastic people.

He Wei

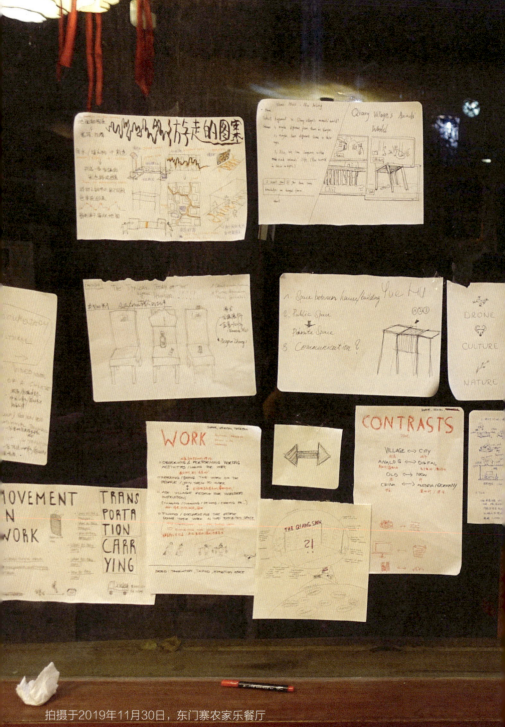

拍摄于2019年11月30日，东门寨农家乐餐厅
Photo taken on Nov 30, 2019 in the restaurant of Dongmen Village

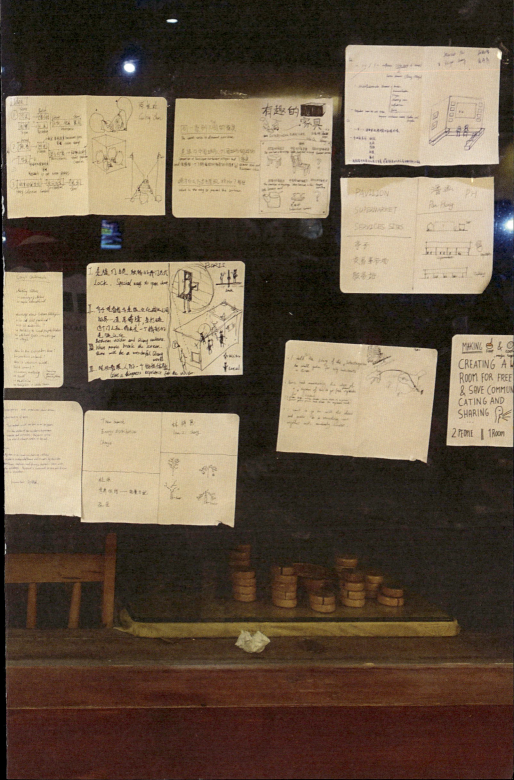